A NATURAL HISTORY OF
TRAIL RIDGE ROAD

A NATURAL HISTORY OF
TRAIL RIDGE ROAD

..

ROCKY MOUNTAIN NATIONAL PARK'S
HIGHWAY TO THE SKY

◆ ◆ ◆

AMY LAW

THE
History
PRESS

Published by The History Press
Charleston, SC 29403
www.historypress.net

Cover images: Front top and bottom and back top right, Amy Law; back top left, USGS; back bottom right, Robert Law; back bottom left, Dick Vogel.

First published 2015

Manufactured in the United States

ISBN 978.1.62619.935.4

Library of Congress Control Number: 2014956340

Notice: The information in this book is true and complete to the best of our knowledge. It is offered without guarantee on the part of the author or The History Press. The author and The History Press disclaim all liability in connection with the use of this book.

This book is dedicated to my mom, who taught me that writing should paint pictures in the mind; my dad, who taught me that every photograph should tell a story; my husband, who told me to follow my passion; and my kids, who came along for the ride.

"Be aware of wonder."

—*Robert Fulgham,*
All I Really Need to Know I Learned in Kindergarten

CONTENTS

CONTENTS

Contents

Acknowledgements

Many people helped to make this book. My thanks to Liz Law-Evans, who let me pick up her idea when she put it down; Dick Vogel, for the use of his outstanding photographs; Michele Simmons of Rocky Mountain National Park and Dave Lively of Grand County History, for taking the time to talk to me; and to all those who helped me put it together by editing and critiquing. Many, many thanks to you all.

INTRODUCTION

Colorado perches at the top of the continent. The average elevation of Colorado is higher than the highest point east of the Mississippi. Colorado has more mountains over 14,000 feet (4,267 meters) than all the other states combined. Four major rivers—the Colorado, the Arkansas, the Platte and the Rio Grande—have their headwaters in the Colorado Rockies. The first of these rivers flows west to the Pacific, while the other three flow east to the Gulf of Mexico. The direction that they flow is determined by the Continental Divide, which runs down the spine of North America.

The highway that crosses the Continental Divide in Rocky Mountain National Park is Trail Ridge Road. With 10 miles above 11,000 feet (16 kilometers above 3,353 meters), Trail Ridge Road is one of the highest paved roads anywhere in the world. It follows an ancient trail along a spine of mountains through the park to cross the Continental Divide. Trail Ridge Road is world famous, and for good reason—the views are spectacular, and the ecosystems are unique. There are few other places in the world where you can experience the high alpine. Trail Ridge Road is Rocky Mountain National Park's "Highway to the Sky."

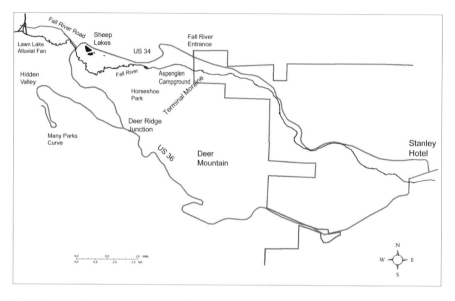

U.S. 34 passes from the open park of Estes into Rocky Mountain National Park. Deer, elk and even bighorn sheep are often alongside the road. *Courtesy the author.*

Chapter 1
ESTES PARK TO FALL RIVER ROAD

Mountain Meadow Community

ESTES PARK

Elevation 7,522 feet (2,293 meters)

Most people begin their journey up Trail Ridge Road from Estes Park. The town sits at 7,522 feet (2,293 meters). To the south, granite Longs Peak and Mount Meeker surge to almost twice that height.

You know you're in Estes when you see the grand Stanley Hotel, built by F.O. Stanley, to the north of the intersection of U.S. 34 and U.S. 36. F.O. Stanley and his twin brother, F.E., were inventors of an amazing variety of things. They are best known for the Stanley Steamer, an automobile that was powered by a lightweight steam engine. The brothers also invented the process to develop film and sold the patent to the Eastman Kodak Company. The inventions made them fortunes.

But in 1903, F.O. Stanley was diagnosed with tuberculosis; his doctor told him that he had only months to live. Like thousands of others, Stanley came to the thin, dry air of Colorado looking for a cure. He stayed in Estes Park during the summers and, as he recovered, began to take an active part in the growing town. He used his reprieve to help develop Estes Park as a resort.

In 1907, Irish Lord Dunraven sold the Estes Park Hotel and the last of his land to B.D. Sanborn and F.O. Stanley. When the Estes Park Hotel burned to the ground in 1909, Stanley spared no expense to rebuild it. He

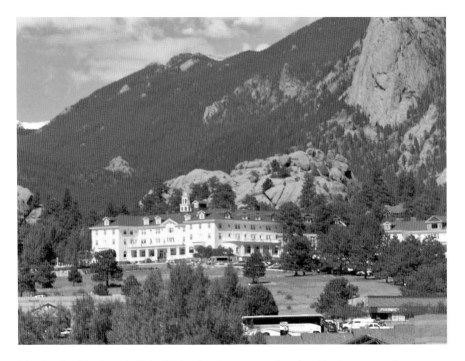

The Stanley Hotel was built in 1909 to be the most modern hotel in the country. Its amenities included electricity in every room. *Courtesy the author.*

paid $500,000 cash to build the most modern luxury hotel in the country; every room was wired for electricity. The big-name, wealthy patrons of the day came to visit, including Margaret ("Molly," a nickname she hated) Brown, John Philip Sousa, Theodore Roosevelt and the emperor and empress of Japan.

A resort needs roads to bring in vacationers. When he bought the Estes Park Hotel, Stanley immediately donated funds to build the North St. Vrain highway to Lyons (now U.S. 36). With the new road, Stanley Steamers could make the trip to the plains in just five hours!

During his last thirty-seven years, Stanley became one of Estes's biggest boosters, building the town water system, as well as Fall River Hydroplant, just below Cascade Dam, for electricity. Stanley also donated land for parks and schools and constructed the town golf course, as well as the fairgrounds that go by his name.

But F.O. Stanley's biggest contribution was one given to the country as a whole. Along with Enos Mills, Abner Sprague and others, Stanley encouraged the establishment of Rocky Mountain National Park. Their

The Twin Owls granite rock formation, on the north side of Estes Park, is a great example of granite weathering into rounded boulders. *Courtesy the author.*

goal was to preserve part of the Colorado Rockies from mining, logging or ranching. They succeeded in having Rocky Mountain National Park set aside in 1915.

F.O. Stanley lived to be ninety-one, returning often to the hotel that he built in the town that he loved.

The Stanley Hotel is said to be haunted. *The Shining*, Stephen King's classic horror novel, was inspired by a stay at the hotel.

West of Estes Park Village, granite, formed as life began on the planet, crowds the canyon along the highway.

What's a Park?

When in Estes, terminology gets a little confusing. There is the "park" (meaning Rocky Mountain National Park), there is the "park" (meaning any of the open valleys in the region) and then there is the "park" (meaning Estes Park Village).

Using the word *park* to mean a high valley surrounded by mountains is a holdover from the French Canadian fur trappers who explored the Rockies in the 1800s to 1840s. For them, a *parc* was a broad valley. American

mapmakers adopted the habit but changed the spelling to suit their English-speaking readers.

The Arapahos called the mountain parks "game bags" because of all the game that could be hunted in them. Wildlife still comes into Estes Park today.

Valley and Mountain Winds

Estes Park has a mild climate that has attracted people for ten thousand years. The climate is produced, in part, by a phenomenon called "valley and mountain winds." Valley winds develop when the sun warms a mountain valley, and the air begins to rise upslope. As night falls, mountain winds blow as the air cools and settles back down the valley. I imagine the land "breathing" in long, meditative breaths: in during the day, out at night. Very Zen.

Valley and mountain winds are the same as land and sea breezes, only inland. Valley winds often bring moisture to higher altitudes, causing puffy cumulus clouds to form over mountain peaks. Mountain and valley winds blow so frequently up and down the park that they mix the air like giant fans throughout the winter, giving Estes Park a climate similar to Denver's but two thousand feet higher. Estes Park's climate is still five degrees colder than the plains, but the park gets about the same amount of snow as Denver, a relatively small amount compared with some places in the mountains.

Fall River Park Entrance

Elevation 8,000 feet (2,438 meters)

There were at least three separate periods of prolonged cold and snow in the Rocky Mountains during the Ice Age. Each produced glaciers that flowed out of the mountains. The Fall River glaciers ended about where the boundary of Rocky Mountain National Park is today.

When the glaciers flowed out of the mountains, they scraped everything out of their way and carved into fresh rock. These rivers of ice pushed sand, gravel and boulders into huge piles along the sides and at the end of their paths, much like a snowplow piles up snow. The thousand-foot-high mounds of gravel are called "terminal" (end) and "lateral" (side) moraines.

The last Fall River glacier flowed out of the mountains 23,500 to 21,000 years ago. It dropped gravel and boulders to form a terminal moraine just

inside the national park. Aspenglen Campground is nestled between the most recent terminal moraine and a lateral moraine. The terminal moraine dammed Fall River and created a lake where Horseshoe Park is now. The glacier then receded up the valley.

Horseshoe Park

When the first humans saw Horseshoe Park ten thousand years ago, it was still a shallow lake. But Horseshoe Park Lake quickly (at least in geological time) filled up. Glacial meltwater washed dead plant material, sand, gravel and clay down from the surrounding mountains to create a mountain meadow. Now, Fall River meanders across flat Horseshoe Park.

Mountain Meadow Community

Mountain meadows are dominated by grasses and shrubs that attract large grazers. Small herds of bison (buffalo) used to be found in these mountain parks, but now the main grazers are elk. Mule deer and bighorns use the community to a lesser degree.

The elk use different plants in different seasons. In spring and summer they eat tender young grass, and in fall and winter they eat high-energy shrub tips, such as willow, wild rose and currant. Rocky Mountain National Park is on the edge of the maximum number of elk that it can hold in winter; in some areas, the elk have browsed the shrubs to death. To help the shrubs recover, the National Park Service has fenced portions of the meadows to keep the elk out.

Up until the early 1900s, wolves were the top predators in mountain parks. Now, population control of the plant eaters is left to Red-tailed Hawks, Golden Eagles, weasels, badgers and the occasional coyote.

Douglas-Fir Forests

The forest is denser on the moraine across Horseshoe Park to the south than it is north of the highway. Douglas-fir trees grow on the cooler, moister north

slope. Often, blue spruce are mixed among them along creeks and rivers, and limber pine may live on the harsher, exposed outcrops. The understory of this community is mostly shade-tolerant shrubs such as juniper and kinnikinnik. Grasses don't grow well in the low light beneath the trees.

Contrary to most assumptions, deep, dark forests don't support as many animals as ponderosa pine savanna or mountain meadow communities do. There are few animals that eat bark or needles and fewer that eat the trees themselves. Animal life includes squirrels, skunks and other rodents, as well as woodpeckers and jays. Predators include the ubiquitous coyote and black bear, as well as large raptors such as owls, Coopers and Sharp-shinned Hawks. Elk and mule deer prefer grasses and shrubs over trees, so they tend to stay in the more open areas.

The cooler, darker north slope of the Douglas-fir community stays snowy longer; snow can still linger under the Douglas-fir trees long after it has melted from the ponderosa pine savanna across the creek.

Sheep Lakes Turnout

Sheep Lakes were created when some *huge* ice chunks were left behind in the gravel as the glacier retreated. To the west, you can see U-shaped Fall River Valley. To the south, Deer Ridge Moraine hides Hidden Valley.

In the summer, you can often see elk, mule deer or bighorn sheep at the west end of Horseshoe Park, by Sheep Lakes. These big grazers need lots of salt to digest their food. Salt isn't often found in the mountains, so the salty soil around these ponds is a treat. The animals gather at this natural salt lick.

Coyotes are harder to see but patrol the entire national park, prowling for small animals and scavenging remains of larger ones. At night, you might hear their yipping howls.

Wolves were pushed out of Rocky Mountain National Park in the first part of the 1900s. As of 2015, there are no wolves in Colorado. There are no plans to reintroduce them to Rocky Mountain National Park; the national park just isn't big enough to hold a healthy pack.

There have recently been a few wolf sightings in Colorado: one in North Park and one near Idaho Springs. If wolves come in on their own, they would be protected by the Endangered Species Act. A return of wolves would be bad news for coyotes, though. Wolves kill coyotes when they find them.

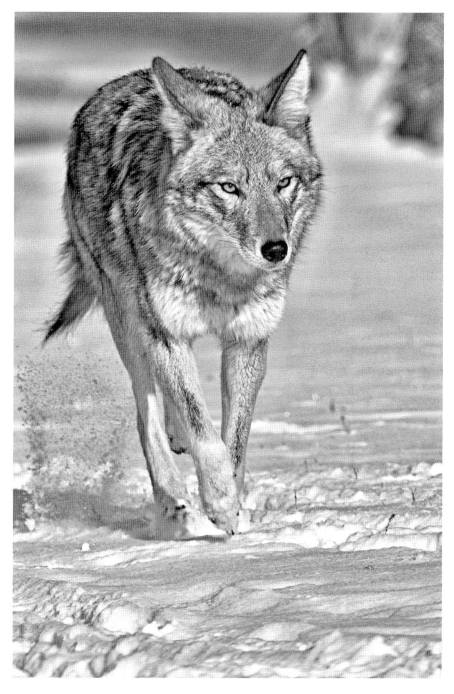

Coyotes roam throughout the Rocky Mountains and the West. In many areas, they are the top predator. *Courtesy Dick Vogel.*

Fall River Road Turnoff

Elevation 8,520 feet (2,597 meters)

The Utes and, later, Arapahos used three trails to cross from Estes Park over the Continental Divide to Middle Park: the Dog Trail (Fall River), the Child's Trail (Trail Ridge and portions of what we call the "Ute Trail") and the Big Trail (Flattop Mountain at the west end of Glacier Basin, above Bear Lake).

The Arapahos called the track that goes up Fall River Road the "Dog Trail" because they used dogs to pull *travois*—A-frame drags made of long, skinny poles—up over the pass, especially when there was snow on the ground.

Children had to get off their horses and hold on to their horses' tails to get up the steepest parts of the Child's Trail over Trail Ridge Road. The hardest route, the Big Trail, followed the Flattop Mountain–Tonahutu– Green Mountain Trail over Flattop Mountain, just north of Hallets Peak above Bear Lake, to the Kawuneeche Valley. It was used by warriors, traveling fast. Tough people.

Fall River Road was built with convict labor between 1915 and 1920, joining Estes Park and Grand Lake over the Continental Divide for the first time. But tight curves and steep grades created problems. How steep and how tight? At one point on Fall River Road, cars had to make a three-point turn to get around a hairpin curve. At other places, cars simply backed up the road because a Model T's reverse gear was lower than its lowest forward gear—using the absolute lowest gear was required to climb the steep road. Fall River Road would never be heavily traveled.

Although still dirt, in the intervening century Fall River Road has been improved for an easier driving experience.

Sundance Mountain

Sundance Mountain, to the west-southwest, was named by a miner with a claim on Fall River above Chasm Falls who used to watch the morning light dance on the mountain.

Lawn Lake Alluvial Fan

Three-quarters of a mile up Fall River Road is the Lawn Lake Alluvial Fan, created when Lawn Lake dam burst (discussed in the section about the Rainbow Curve turnout). Deer Ridge, to the south, is a lateral moraine, a five-hundred-foot-tall pile of gravel that splits Horseshoe Park from Hidden Valley to the southeast.

Ponderosa Pine Savanna

The open ponderosa pine forests that cover the slopes north of the road are called "savannas." Ponderosa savannas are hotter and drier than any other community in Rocky Mountain National Park.

Ponderosas need to be widely spaced because if they get crowded, they are prone to insect attack and disease, and they may burn in a hot crown fire.

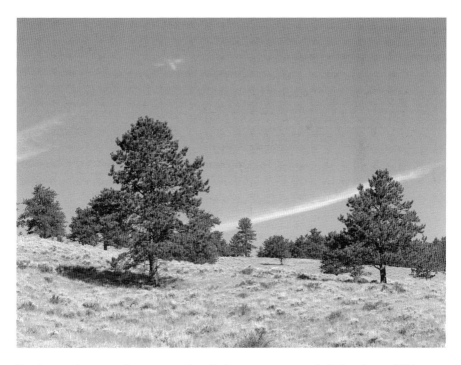

Ponderosa pines grow in open stands called savannas, on south-facing slopes. With plenty of grass growing beneath the trees, the savannas are favorite areas for elk and deer. *Courtesy the author.*

To survive the light ground fires that clear out the undergrowth, the big trees have evolved thick red bark that protects older trees.

The open forest also allows plenty of light to get through the canopy to grow a good stand of grasses and mountain shrubs. Mule deer and elk use these plants for browsing and cover. More widely spaced trees will develop larger crowns, resulting in heavier seed crops for wildlife and more forage for deer, elk and bighorn sheep.

This means that you'll find more animals in the ponderosa savannas than any other forest community. Elk love to graze under the stately trees, as did buffalo. Mule deer browse on the nutritious tips of shrubs. Bighorn sheep venture off the mountain slopes and onto the grasslands in search of salt. Squirrels, skunks and other rodents, Clark's Nutcrackers and Gray Jays forage for seeds, while Mountain Bluebirds flit in and among the big trees.

Where there are plant eaters, there are meat eaters. Mountain lions hunt deer and sometimes elk, as do occasional packs of coyotes. Large raptors such as Red-tailed Hawks and Golden Eagles hunt anything smaller than themselves. Wolves and grizzly bears used the open ponderosa forests before they were pushed from the state. Black bears are common in this community, scavenging and digging up roots.

People have used the ponderosa savanna for thousands of years. Utes used the inner bark of ponderosa as a food source due to its sweet taste in good times and as a starvation food in bad times. They used the wood for tools.

Elk in Horseshoe Park

Hundreds of elk jam Horseshoe Park and Beaver Meadows in the fall during mating season, called "rut." *Do not* approach them. Their brains are focused on defending their territory and their harems from all intruders. Intruders, in this case, means "anything that moves besides me and my harem." In the evenings and early mornings, you can hear their eerie whistle-like "bugles."

Lord Dunraven

Lord Dunraven, an Irish earl visiting Estes Park in 1872, saw the mountain meadows, the ponderosa savannas and the elk grazing the grasses in them. He determined then and there to buy up the area as a private ranch and hunting preserve. By 1880, Dunraven owned 8,200 acres and controlled

another 7,000 acres by owning access to springs and streams, a very common tactic in the semi-arid West. Dunraven's minions used every trick they could think of to run other settlers out of the area.

Dunraven's efforts were stymied by "Rocky Mountain" Jim Nugent, Abner Sprague, Enos Mills, F.O. Stanley and other area residents. They thought that he had the right idea in preserving the area in a natural state, but they wanted it to be enjoyed by everyone. When the Americans refused to understand that the park was now Dunraven's private hunting reserve, the earl switched tactics and built the Estes Park Hotel (in Estes Park). He eventually sold the last of his land and the Estes Park Hotel to F.O. Stanley and B.D. Sanborn in 1907.

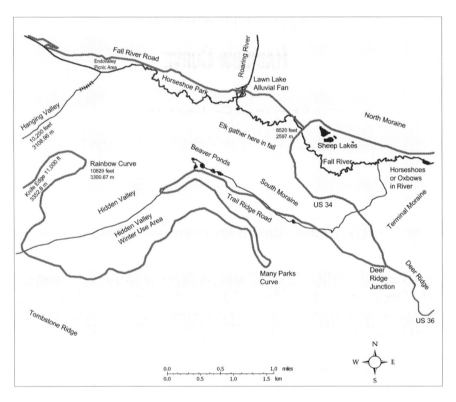

From Fall River Road to Rainbow Curve, Trail Ridge Road climbs from wet mountain meadows to the spruce-fir forest, a gain of 2,300 feet (701 meters). *Courtesy the author.*

Chapter 2
FALL RIVER ROAD TO RAINBOW CURVE

Spruce-Fir Forest

UP DEER RIDGE–SOUTH MORAINE

As you climb Deer Ridge–South Moraine, the highway starts to rise toward the roof of the continent. If you have a GPS, turn it on and watch the elevation click upward to more than 12,000 feet (3,658 meters) in the alpine tundra. The elevation at the Fall River Road turnoff is 8,520 feet (2,597 meters).

Horseshoe Park Overlook

To the northwest, you can see Mount Ypsilon, the mountain with the Y-shaped crevasse, or crack, in the rock. The horizontal portions of the *Y* are flat bands of metamorphic rocks.

Fall River flows from the west down Fall River Canyon and meanders through Horseshoe Park to the east. On either side of Horseshoe Park, you can see the low ridges of lateral moraines, pushed up by the passage of the glacier that moved down the canyon 25,000 to 10,000 years ago. In fact, Horseshoe Park Overlook is on the South Moraine.

Above the moraines, rounded granite knobs stick out of the forest. Water freezing and thawing in the coarse granite grains causes them to pop off, rounding the boulders. As the weight of the rocks above erodes away, entire sheets of rock come loose, creating the layered look of the rocks.

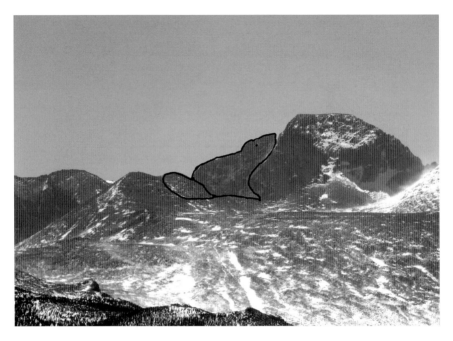

"The Beaver" rock formation is visible from many areas on the east side of Rocky Mountain National Park. *Courtesy the author.*

DEER RIDGE JUNCTION

Elevation 8,937 feet (2,724 meters)

At Deer Ridge Junction, U.S. 34 officially becomes Trail Ridge Road. If you look south, you can see Longs Peak poking above the low hill of Bierstadt Moraine. Lots of people talk about "The Beaver," the rock formation on Longs. Do you see it?

Englemann Spruce–Subalpine Fir Community

The spruce-fir community is a mix of Englemann spruce and subalpine fir. The spruce-fir forests range from about 9,000 feet (2,743 meters) to timberline on both sides of the Divide, forming a band on the mountainside between the lodgepole pine forests and ponderosa pine savannas below and the tundra above.

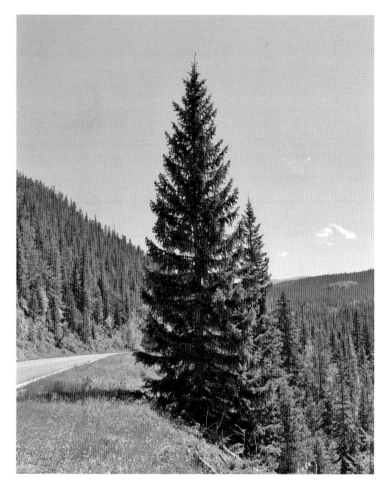

Englemann spruce are the main tree of the spruce-fir forest. This forest catches and holds more snow than any other plant community. *Courtesy the author.*

The spruce-fir forest gets more moisture than any other community in Colorado. Frost-free for only two months out of the year, this community receives most of its precipitation as snow. The deep, long-lasting snows keep many animals out of the spruce-fir forest for six to eight months of the year, and while the dark forest floor has more plants than a lodgepole community, these understory plants aren't tasty to many animals. The animals that are found in these dark forests are ones that eat spruce or fir seeds: red squirrels, Clark's Nutcrackers, Juncos, Mountain Chickadees and Steller's and Gray Jays.

That means that the spruce-fir community doesn't support as many big animals as do the ponderosa savanna or mountain meadows communities

lower down. Elk, deer, coyote, black bear and Ravens pass through on their way to openings in the forest cover.

Abundant moisture and cool climate protect the spruce-fir forests from fire, and in the high mountains, rugged terrain has protected them from logging. These trees can live for 250 to 400 years and are Colorado's largest trees. Wind "throws" (trees blown down by wind), lightning strikes and insects are the biggest hazards to Englemann spruce and subalpine firs.

Because of the short growing season, it takes a long time for the spruce-fir forest to recover from large disturbances like fire or avalanche. Englemann spruce and subalpine fir seedlings must get started under the shade of mature trees. If the forest is burned or cut, fir or spruce trees have to wait for lodgepole pine or aspen to grow and provide cover before the spruce or fir seedlings can survive.

Humans use the spruce-fir forest for water storage because the snow lasts so long here. In late May and early June, if you listen carefully to the weather forecasters in cities along the Front Range, they talk about

how hot days can melt the snowpack too fast and cause flooding. The snowpack that they are talking about is in the spruce-fir forest, where it is finally warming up enough to melt.

Beaver Ponds

The small lakes to the north of the highway were created by those largest of all North American rodents: beaver. Obeying their instincts to quiet moving water, beaver cut down trees, drag them across streams and pack them with mud to make

Blue spruce grow along streams from the foothills to the tundra. *Courtesy the author.*

dams. The resulting ponds protect the beaver by creating a moat for their lodges and by letting them move about in water, an element that most predators avoid. The ponds also encourage the growth of a beaver's favorite foods: aspen, willow and alder—plants that do well in wet soils. Blue spruce grows along the banks of beaver ponds as well.

Other creatures—such as moose, ducks, geese and, of course, fish—use the ponds, too. Eventually, sediments washed into the ponds will fill them, and the ponds will become a small meadow.

Hidden Valley

Starting in 1936, the tows of Hidden Valley Ski Area, nestled in the spruce-fir forest of the pocket-valley to the southwest, pulled skiers above timberline, where the skiing was always challenging. As part of the continuing effort to return the park to as natural a state as possible, the lodge and tows were removed in 1991 and the area reseeded with flowers and grasses among the Englemann spruce and subalpine fir.

People still use the snowy little valley for sledding and tubing, as well as a starting point for ski mountaineering, an advanced form of cross-country skiing.

Above Hidden Valley is Tombstone Ridge. The old Ute/Child's Trail comes up through Beaver Meadows

Subalpine fir grow in areas of cool summer temperatures and deep winter snows. *Courtesy the author.*

and over Beaver Mountain farther south to join Trail Ridge Road on top of the Ridge.

Many Parks Curve

Elevation 9,664 feet (2,946 meters)

From here, you can indeed see many parks: Horseshoe Park, Little Horseshoe Park, Hidden Valley, Beaver Meadows and Moraine Park.

Trail Ridge Road is closed from Many Parks to the Colorado River Trailhead on the Western Slope from sometime in October to early June. The exact opening and closing dates vary with the weather.

Chipmunks, golden-mantled ground squirrels, Gray Jays, Steller's Jays and Clark's Nutcrackers descend wherever visitors stop, hoping for a handout. Don't give it to them—they need to find their own food.

The Front Range of the Rocky Mountains, in which Rocky Mountain National Park sits, is made up of dark 1.7-billion-year-old metamorphic gneiss and schist, with veins of orange or gray 1.4-billion-year-old igneous granite "intruded" (squeezed) into it. From Sundance Mountain at the Forest Canyon Overlook to Estes Park, you can see good examples of these rocks close up.

Fourteeners

Nearly thirty peaks in Rocky Mountain National Park are over 12,000 feet (3,658 meters) and sixteen are over 13,000 feet (3,962 meters), but only granite Longs Peak, towering to the south, is over 14,000 feet (4,267 meters). Longs Peak (14,259 feet or 4,346 meters) is the most northerly of Colorado's 14ers.

Depending on how you measure them, either fifty-two or fifty-three peaks in Colorado are over 14,000 feet. They are called "Fourteeners" (or "14ers"). No other state has as many 14ers as Colorado, and only one mountain in the continental United States (Mount Whitney, in California, at 14,505 feet or 4,421 meters) is higher than the highest Colorado peak (Mount Elbert, 14,433 feet or 4,402 meters).

Ski Runs of Hidden Valley

Ski runs of the Hidden Valley Ski Area used to cross the road at Hidden Valley Creek, just before Rainbow Curve. The slopes didn't seem this steep when I was a young ski fanatic.

Rainbow Curve

Elevation 10,829 feet (3,301 meters)

Ancient granite makes up the rocks at Rainbow Curve. It also creates the big rounded rock formations that you can see from the Overlook, sticking out of the forest along either side of Horseshoe Park.

Fall River meanders across the valley floor. In the steep mountains, the river has energy to spare and so actively erodes and cuts down. But when the valley flattens out, the river writhes sideways, creating horseshoe loops, or oxbows. If the loops wander so much that they touch, they create oxbow lakes. If this is a little hard to understand, think of a string. When the string is held by one end, it hangs straight. But when the string is laid on a table, and one end is pushed toward the other, the string bunches up. If you keep pushing, the string eventually folds on itself. The same thing happens with rushing water.

Lawn Lake Flood

As you look to the northwest side of Horseshoe Park below, you can see a triangle of relatively bare earth. This is the Lawn Lake Alluvial Fan, site of two floods since 1982.

In 1903, as people began to talk about the area becoming a national park, the Irrigation Ditch and Reservoir Company of Loveland, Colorado, enlarged natural Lawn Lake on the side of Mummy Mountain, to the south. The company built an earthen dam 36 feet high that enhanced the natural dam so that the lake then held 674 acre-feet (831,367 cubic meters) of water. An acre-foot is the amount of water used by a family of five in a year.

Being in such a hard-to-get-to place, it was difficult for the owners to maintain the dam. Lead caulking between the outlet pipe and valve gates leaked, letting trickling water erode the earthen dam. At 5:30 a.m. on a summer morning in

1982, the dam failed. A wave estimated to have been twenty-five to thirty feet high flushed water and debris down the valley. A hiker camped along the banks of the Roaring River was drowned as he slept.

An alert Park Service employee at the Lawn Lake Trailhead heard a roaring that "sounded like a freight train." He reported the flooding. The water rushed on. It filled Horseshoe Park and topped Cascade Dam. When Cascade Dam burst, the water of Cascade Lake was added to the flood. Fall River Hydroplant, just below Cascade Dam, built by F.O. Stanley in 1909, was ruined.

Aspenglen Campground was ordered evacuated at 7:23 a.m. Just twenty-five minutes later, everybody was out. But two campers were killed when the course of the raging floodwaters suddenly changed. The water broke through the Department of Wildlife fish hatchery just outside the park and funneled into the narrow granite canyon. By 8:12 a.m., the water hit Estes Park Village and flooded the downtown area. Lake Estes rose *two feet*, but the dam held. The floodwaters caused millions of dollars in damage, but no further lives were lost.

After the failure of the dam, the Lawn Lake dam was removed, and the lake returned to its original size. The National Park Service also evaluated Bluebird, Sandbeach and Par Lakes, and their water levels were immediately reduced. Their dams were removed between 1988 and 1990.

Lawn Lake Alluvial Fan

When the water gushed out of the narrow Roaring River Canyon into Horseshoe Park at Endovalley, it spread out and dropped the load of debris that it had picked up on its rampage down the canyon, including boulders nine feet in diameter. The debris created an instant alluvial (river-made) fan of debris. This fan is the bare spot that you see in the valley below you.

The alluvial fan soon had a few plants poking up through it. Ecologists call these plants "pioneer" species. Pioneer plants can survive direct sun and bare ground. They begin the settlement of the raw earth. Over the years, they will be succeeded by a series of plants until the debris is hidden to all but the most curious visitor.

2013 Flood

More gravel and cobblestones swept down the Roaring River in the September 2013 floods, when a week of torrential rain dumped between nine and sixteen inches of water on Colorado—as much as the state sees in a year! This flooding deposited more boulders, sand and mud and set the plant succession back thirty years.

If you take the Fall River Road turnoff on the way to Endovalley Picnic area, you can take a short hike over the debris field and see firsthand just how big the boulders that the water carried down really are.

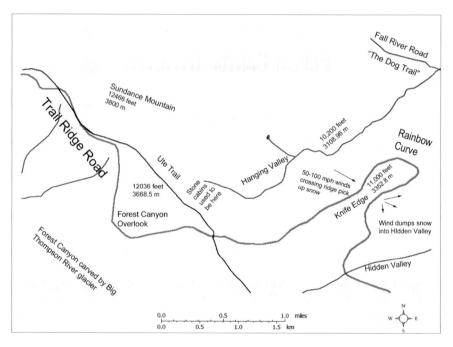

Trail Ridge Road from Rainbow Curve to the Forest Canyon Overlook is the transition from the spruce-fir forest, through the krummholz, to the tundra. *Courtesy the author.*

RAINBOW CURVE TO FOREST CANYON OVERLOOK

Krummholz

TOMBSTONE RIDGE

Between Rainbow Curve and the Forest Canyon Overlook, Trail Ridge Road runs along the top of Tombstone Ridge. This section of Trail Ridge Road passes through large areas of krummholz, with forest on the lower side and tundra on the upper slopes.

Crooked Wood

The trees that grow at timberline are stunted, bent and twisted. If you ever wanted a definition of the word *gnarled*, some of these trees would provide it. Their broken branches tell the story of enduring hurricane-force winds. When the trees are left with branches only on the leeward side, they are called "flag" or "banner" trees. Flag trees can be found in any place where the wind blows hard from one direction, but they are most pronounced at timberline. In more exposed places, the trees can't grow up, so they grow along the ground, where the wind is not quite so fierce. This transition between forest below and alpine tundra above is called *krummholz*, which means "crooked wood" in German.

The dominant trees of krummholz in Rocky Mountain National Park are the aptly named subalpine fir and Englemann spruce; on windy sites,

Years of hurricane-force winter winds have broken the branches off one side of this subalpine fir to turn it into a "flag" or "banner" tree. *Courtesy the author.*

limber pine grows among the rocks. With only two frost-free months per year, the trees grow exceedingly slowly. Trees hundreds of years old may be just inches in diameter and a few feet tall, adding only millimeters of wood in a growing season.

Englemann spruce and subalpine fir have evolved several strategies to survive as high on the mountain as possible. The first is by "layering," or sending out roots from branches. This allows a tree to spread anywhere a branch touches the ground. Layering is very useful when the growing season is too short for a plant to produce seeds.

The other way that trees survive in krummholz is that they often grow in "tree islands," protecting one another from the wind. These tree islands get started when a tree sprouts in the lee of a rock or a dead stump. Slowly it grows up a little and out a bit more. Other trees survive in the lee of the first and spread the tree island out farther. You can see how layering would help to build up a tree island. Even when a tree dies, its stump still breaks the wind for the others in its lee.

Krummholz is an edge area, providing the best of the forests below and the tundra above. It is an important area for animals. In summer, deer and elk rest here under the cover of the twisted trees after grazing in the tundra, while Ptarmigan use the same islands of trees in winter.

This community specializes in living on the edge. Any disturbance—such as clearing plants away for a campsite, gathering wood to put in the rock

garden at home or global climate change—hits krummholz hard; it takes centuries for the community to recover.

Ancient Game Drive

In the fall, bighorn sheep congregate in the tundra on the Knife Edge ridge above the highway for rut, or mating; elk and deer migrate across the ridge to wintering grounds lower down. Starting about five thousand years ago, native people began building "game drives" on the ridge to hunt these animals.

This hunting method was not a "game jump," where animals were stampeded over a cliff. Instead, small bands of people urged elk, deer or bighorn sheep between low rock walls, where the animals could easily be killed using nets, spears, atlatls and, later, bows and arrows. The people might bag half a dozen animals this way. The high alpine game drives were abandoned once the Utes got horses, in about 1700. Similar game drives were used in the Arctic into the 1920s.

The Knife Edge

The wind along the Knife Edge ridge above the highway blows constantly in the winter. Backcountry skiers or snowshoers who come up here can count on it howling at fifty miles per hour, with gusts up to one hundred miles per hour. Winter temperatures can sink to -40°F (-40°C), and average summer temperatures in the warmest month are around 50°F (10°C).

As the wind howls up the slope, it picks up snow, scouring this side of the ridge clean. When the wind crosses the ridge, it drops the snow, piling it even deeper on the lee side. Because of this extra snow, glaciers start on the lee side of mountains throughout the park. Hidden Valley, on the far side of the ridge, is the recipient of the wind-blown snow from this slope. The extra snow allowed Hidden Valley to host a small ski area from the 1930s to 1991.

Life Above Timberline

How hard is life above timberline? Starting in January 1971, Katherine Bell, a PhD student from the University of Alberta, and Emily Dixon, her research assistant, found out. The women spent four months above timberline in a small stone cabin on Sundance Mountain, just to the northwest, a mile and a

half from the top of the upper lift of the now-gone Hidden Valley Ski Area. Bell was studying how a small grass-like plant called *Kobresia spp.* continues to photosynthesize on windswept slopes through an alpine winter.

The cabin was one of several built in the 1920s for crews working on Trail Ridge Road. Although the cabin had no electricity, it had an oil-burning furnace for heat and was built in a small swale so that it was relatively sheltered from the fifty- to one-hundred-mile-per-hour winds that regularly swept the slopes. Before Trail Ridge Road closed for the season, Robinson hauled up plenty of canned food so that she wouldn't have to worry about eating through the winter.

But the furnace didn't work well—the fuel oil thickened in the bitter cold, and there were other fuel line problems. The interior of the cabin rarely got above freezing, so bathing was out of the question. The women ended up wearing their outdoor clothes to bed. They ate their food frozen solid. Throughout their stay, the winds were normally around fifty miles per hour. The wind chill turned cold days into dangerously cold days. Fieldwork was very difficult, as the women risked frostbite every time they took their mittens off to measure the tiny plants and record the data.

The women went down to Estes Park every ten days or so. Bell and Robinson had to learn how to cross-country ski so that they could get to their sites and down to the base of Hidden Valley to get to town. To get down, they had to go across the Knife Edge just west of Rainbow Curve to Hidden Valley to the southeast. With gusts over one hundred miles per hour, the winds over the Knife Edge were strong enough to pick the women up and hurl them back down. Sometimes they had to slither across the gap on their bellies.

Between the bitter cold, fighting the wind, traveling over the snow on skis and the simple physiological effort of living with one-third less oxygen, the women lost ten to fifteen pounds, in spite of consuming twice as many calories as normal. But perhaps the hardest part of life above timberline was the isolation. Twelve weeks of snow and howling wind strained the women's endurance. Only tremendous determination to finish the job saw them through. But they made it until April. Bell and another woman went back for a shorter stay the next winter.

The Stone Cabin was torn down a few years after Bell finished her research, in the mid-1970s.

Sundance Mountain

Trail Ridge Road runs along a knob of Sundance Mountain. Look across Forest Canyon to the southwest to see the Continental Divide. From here to the Gore Range Overlook, the highway roughly follows the ancient trail used by the Arapahos, Utes and older groups. The trail came up Tombstone Ridge from the east to get to Grand Lake on the other side of the Continental Divide.

Timberline

The timberline here is between 11,000 and 11,500 feet (3,353 meters and 3,505 meters). Timberline is the line on a mountain where trees can no longer grow. It can be a little higher or lower depending on which direction the slope faces. North- or west-facing slopes will have a lower timberline. You can also have timberline as you go toward the North or South Poles, but the change is much more gradual.

But *why* won't trees grow here? In general, temperatures get colder with elevation—typically 4°F to 5°F per 1,000 feet (305 meters). So, on average, it is 27°F cooler here than in Denver or 45°F cooler than Washington, D.C., or Philadelphia, Pennsylvania.

In winter, it doesn't matter how cold it is because plants are dormant, but low summer temperatures mean a very short growing season for plants in the krummholz. Below average summer temperatures of about 50°F (10°C) in the warmest month, trees can't grow. Add to this the howling winter winds of over one hundred miles per hour that literally blast the branches off the windward side of trees, and the elements eventually become too much for even the most determined trees to survive. And so, no trees grow above timberline, only highly specialized alpine plants.

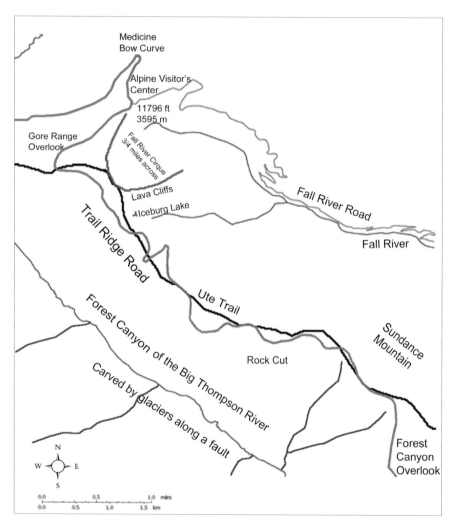

From Forest Canyon to the Alpine Visitor's Center, Trail Ridge Road is entirely above 11,500 feet (3,505 meters), and so above timberline. *Courtesy the author.*

Chapter 4

FOREST CANYON OVERLOOK TO ALPINE VISITOR'S CENTER

Alpine Tundra

FOREST CANYON OVERLOOK

Elevation 11,760 feet (3,585 meters)

From here, you can see the deep, straight, U-shaped valley gouged by a glacier to form Forest Canyon of the Big Thompson River, 2,500 feet (726 meters) deep. The mountaintops seen from Trail Ridge Road are gently rounded, until you come to the edge of the ridge, when the slope plunges down thousands of feet. The steep slopes were cut by glaciers.

These mountains began to rise 70 million years ago and finished 6 million years ago. By the end of the uplift, erosion by streams had worn them down to create a high gentle upland terrain. The tops of Longs, Terra Tomah and Stones Peaks are surprisingly flat and smooth because they are the remnants of these rolling hills.

The Big Thompson River followed the faults and cracks that developed as the mountains rose and the land stretched. Falling from a greater height, streams had more energy to cut into the mountains. Eroding sediments added grit to help cut valleys.

About 2.0 to 1.8 million years ago, the Earth's climate cooled. With a cooler climate and higher altitude, more snow fell and slowly built up into snow and ice fields. When the snow depth reached about 200 feet, it began to flow, turning a snow field into a glacier. The weight of the ice, with rocks

acting as sandpaper, cut down, creating U-shaped valleys beneath the rolling uplands and straightening the canyon further as it ground away the curves. Forest Canyon glacier was 13 miles (21 kilometers) long from the head of Forest Canyon to the terminal moraine in Moraine Park and 1,000 to 1,500 feet (305 to 457 meters) deep.

Glaciers create some unique landscapes. Forest Canyon has "hanging valleys," where smaller glaciers fed into larger ones—you might see these as waterfalls or rapids. Bowl-shaped "cirques" were created as snow and ice built up at the top of the glacier. Those cirques that are now filled with water are called "tarns." Across the canyon, you can see cirques and tarns "stair-step" down the gorge in Terra Tomah. The vast majority of Colorado's naturally occurring lakes are small lakes like these above 9,000 feet (2,743 meters).

THE ROCK CUT

Elevation 12,200 feet (3,718 meters)

In the harsh world above timberline, alpine plants hug the ground and use creative strategies to catch sunlight and keep heat. Here, on the top of the continent, are some of the most unique plants in the world—tough yet delicate. These plants can take extremes of weather but can't hold up under footsteps. Don't walk on the plants!

Construction of Trail Ridge Road

After Fall River Road opened in 1920, the number of visits to Rocky Mountain National Park jumped as people came to experience the incredible scenery and unique environments. This is not to say that Fall River Road was an easy road to drive. It was not. Especially on the east side, Fall River Road was steep and had extremely tight hairpin turns that required backing up and going forward several times to work around them.

The National Park Service quickly realized that a better road would allow even more people to experience the wonders of the upper reaches of Rocky Mountain National Park. In 1929, two contractors started work on either end of the new road, following the old Ute's/Child's Trail across Tombstone Ridge.

Recognizing that the ominous sound of the name "Tombstone Ridge Road" might scare visitors, the Park Service changed the name to Trail Ridge Road.

The crew working on the east side of the park was based at Hidden Valley but had a camp of several stone buildings high on Sundance Mountain. The crew working from the west came up from Squeaky Bob's tent resort. Since the portion of the Fall River Road from Squeaky Bob's to the Fall River Pass (where the Alpine Visitor's Center is now) was very gentle, the western workers had a much easier time.

The construction crews did what they could to lessen the environmental damage of building the road. They built blast walls of logs and rocks to minimize the amount of debris scattered by explosions. Displaced rocks were returned to a lichen-side-up position. Supervisors cruised the road to check quality.

By 1933, the two work crews had finished. Trail Ridge Road traversed a remarkable ten miles above 11,000 feet, allowing people to pass briefly through a realm of spectacular scenery and amazing plants and animals. And the road's steepest grade was just 7 percent, a great improvement over the old Fall River Road and comparable to the steepest grades allowed on highways today. No backing up required anywhere.

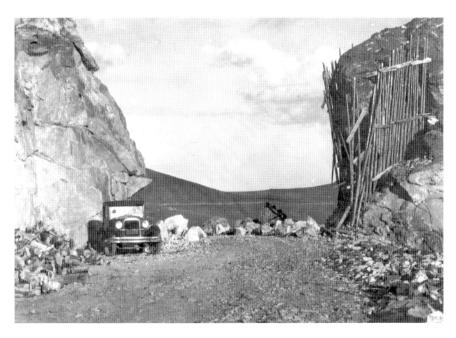

Trail Ridge Road construction at the Rock Cut, circa 1932. Contractors took great care to minimize damage in the tundra. *Courtesy National Park Service.*

Alpine Tundra Community

The alpine tundra, from treeline to the tops of the highest mountains, has by far the most severe climate of anywhere in Colorado. More than 2.5 miles above sea level, the jet stream that brings cold air howling down from the North Pole sometimes dips down to buffet the tops of the mountains with winds that can reach 155 to 200 miles per hour. Snow doesn't so much fall up here as blast across the land surface. Drifts twelve feet (3.7 meters) deep build up as snow is scoured free of nearby outcrops and drops into depressions. Winter temperatures can plummet to -40°F (-40°C) or more. The soil may never thaw out from one year to the next, and the snow may never completely melt, forming ice fields and, eventually, glaciers that can creep down the valleys, bulldozing everything in their paths.

To cope with this extreme climate, alpine plants have evolved some amazing adaptations. Above timberline, all the plants hug the ground to escape breakage by either snow or blasts by wind. Virtually all the plants up here are perennials, living more than one year. Most of an individual plant is underground, in the root mass, where the climate is relatively mild.

A thick blanket of snow is a great insulator. When the wind is blowing with hurricane force at subzero temperatures on the surface, the conditions beneath the snow will be just below freezing and calm. Plants that grow where the snowdrifts linger don't have to worry about the intense cold or howling winds that freeze more exposed areas. But these plants stay just below freezing for six to nine months every year, and during that time, they get no direct sunlight.

Willow thickets are the most obvious plants to use this strategy of surviving under the snow. They grow in depressions on the lee (protected) side of rock outcrops. Snowdrifts here may be many feet deep, protecting the shrubs from the harsh effects of the wind and cold but threatening to break them under the weight of the snow and depriving them of direct sunlight for six months of the year.

Where the snow cover is scoured away, plants are exposed to the frigid, drying winds. The plants that grow in the open are especially low growers, called "cushion" or "mat" plants. While benefiting from extra sunshine, they grow in low, rounded shapes, hugging the ground to minimize the wind resistance. The low plants live in between the rocks in "fellfields," or they make up the lawn-like "turfs" that form the surface of much of the alpine tundra. To conserve water, these plants have hairs or a waxy coating, as well as small leaves. The rocks themselves are covered with lichens, those happy symbiotic marriages of algae and fungi.

The blossoms of alpine plants are large compared to the rest of the plant, making this a tundra flower garden. Alpine sandwort, moss pink (a carnation), arctic gentian, alpine avens and other tiny plants thrive to produce large, beautiful flowers in one of the harshest climates on Earth.

The short growing season means that life moves slowly; yearly plant growth up here is measured in centimeters. Often plants cannot produce seed every year. Instead, they hoard any excess energy and nutrients from year to year, blooming every other year, or less. Many alpine plants give up on reproducing by seed most years and spread by growing in mats or by sending out runners.

One of the most amazing adaptations of tundra plants is their use of purple pigments to turn sunlight into heat, as antifreeze and as sunscreen to protect against excessive ultraviolet light. When green chlorophyll dies off in the fall, these pigments show their true colors, turning the tundra burgundy red and burnished gold.

These are some of the toughest plants in the world, thriving in an ecosystem few people even visit. And yet, in their own way, they are fragile. When it takes years for a plant to grow inches, a mouthful by an elk may consume a decade of growth by these plants. Sharp hooves cut up plants, and hiking boots crush fragile stems. If you pick the flowers, you have just ruined the plant's ability to produce seeds for the entire year, maybe two—or maybe for the life of the plant. Recovery of the tundra after disturbance is the slowest of any of the plant communities, taking hundreds to thousands of years. Be careful up here.

Compared to any other habitat, very few animals live in the tundra. Most animals up here use one of two strategies for dealing with the cold: they burrow into the snow or they migrate down to lower altitudes for the winter. Yellow-bellied marmots hibernate in underground dens in the winter, and pocket gophers and rabbit-like pika build tunnels beneath the snow to get to their foraging areas. Mule deer and elk fatten up on the alpine plants in the summer and then migrate to lower elevations.

Only bighorn sheep, Ptarmigans and foxes tough it out, hunkering down in burrows or the lees of willows when winter storms rage and coming out when the winds die down.

Iceberg Pass

The top of the ridge between Forest Canyon Overlook and Lava Cliffs is rolling upland terrain typical of the tops of many of the mountains in Rocky Mountain National Park. These upland areas weren't carved by ice

Longs Peak from the Tundra Curves Overlook. Snow can fall on Trail Ridge Road any day of the year. *Courtesy Robert Law.*

as the valleys were but rather are hilltops left over from before the glaciers. Although the great glaciers are gone, howling winds in the alpine tundra still drop snow in depressions. Often the drifts can be twelve feet deep.

Mount Ida, the ridge across Forest Canyon, is made of layers of metamorphic gneiss and schist. To the east, igneous granite Longs Peak pokes its summit above all others.

Lava Cliffs and Iceberg Lake

Elevation 12,000 feet (3,658 meters)

The Lava Cliffs are indeed made of reddish ash from exploded lava. The ash seems to have flowed here from a volcano in the Never Summer Mountains to the west, possibly Red Mountain, 29 to 24 million years ago.

The ash of these red cliffs is made of rhyolite, a volcanic form of granite that cooled a bit in the magma chamber before the chamber exploded. The cooling allowed crystals of feldspar and quartz to form. When the chamber

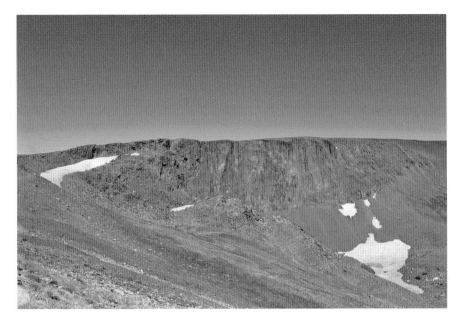

Lava Cliffs above Iceberg Lake. Snow collects below the lip of the cliff and fills the lake below. *Courtesy the author.*

blew, the heavier crystal particles flowed down the side of the volcano as a white-hot ash flow. The ash stopped here and cooled so quickly that brown and black obsidian glass formed.

In the Ice Age, starting 1.8 million years ago, a glacier was born here, carving deep into Lava Cliffs mountain before sliding down the valley to join the Fall River Glacier to the north. Today, all that is left of this glacier is Iceberg Lake, at the base of the Lava Cliffs. The little lake got its name from the ice that stays in it most of the time.

Volcanic Formations

About 29 to 24 million years ago, lava and volcanic ash flowed over the western side of the park. Streams and glaciers have removed most of the volcanic evidence, except for a few spots—the Lava Cliffs and Specimen Mountain to the northwest and the Never Summer Range itself, along the west edge of the park.

High Point

Elevation 12,183 feet (3,713 meters)

The headwaters (beginning) of the Big Thompson River are to the southwest and Mount Chapin of the Mummy Range to the northeast. Remember, we are running along the high ridge of Trail Ridge Road and haven't crossed the Continental Divide yet; this is still the Front Range, where rivers drain to the east, eventually emptying into the Mississippi. The Continental Divide is where the water runs, not the highest line of the mountains.

Watch Forest Canyon below. Bighorn sheep climb among the rocks, and Golden Eagles soar over them.

Gore Range Overlook

Elevation 12,023 feet (3,665 meters)

In the distance to the east, you can see Longs Peak standing above the other mountains. On a clear day, if you look southwest between the Never Summer Range to the west and the Front Range to the east, you may see the Gore Range as a ragged line of blue in the far distance.

Lord Gore

The Gore Range was named for the notorious Lord St. George Gore of Ireland, who left a trail of hunting carnage behind him. This guy was filthy rich, one of the richest men in Great Britain at the time. He got his money as an absentee landlord from estates in Ireland during the Irish Potato Famine (1845–49). Remember that the Famine reduced Ireland's population by one-quarter through starvation, disease and emigration. In 1855–56, Gore left the unpleasantness of the Famine behind and came to the American West to hunt.

Gore blasted a broad swath through the wildlife of America in extravagant style on an extended hunting expedition through what is now Colorado, Wyoming and Montana. Gore brought literally tons of equipment, including

fine linens, crystal, French wines, a collapsible bed, a collapsible bathtub, a fur-lined commode, nearly one hundred guns and packs of hunting dogs. This example of excess required forty men (including one man just to tie fishing flies), one hundred horses, six wagons and twenty-one carts to haul the gear.

For much of the time, Gore was the only shooter on his expedition. He bragged later that over two years, he shot between 1,500 and 2,000 buffalo, 1,600 elk and 105 bears. The slaughter was so wanton that the *Yamparikach*, or Yampa Utes, who lived in northwest Colorado asked him to move out of their territory while there was still some game left for them to survive.

As he prepared to leave the West, Gore tried to sell his equipment to the locals. After being offered what he considered an insultingly low price for it, Gore burned his equipment in a temper tantrum. The Dakotas had the last laugh, though. On Gore's way home, they robbed him of his remaining possessions as he crossed their territory in present-day Wyoming. When he got to civilization, he offered to raise an expedition to do to the Dakotas what he had done to their wildlife. The U.S. Army declined the offer.

On the plus side, people saw what just one selfish individual could do to wildlife and began to think seriously about protecting what they had. It is ironic, though, that we named an entire mountain range after the man.

Divides

A "divide" is simply a ridge that divides two river systems (also called "drainages" or "watersheds"). Trail Ridge is the divide between the Big Thompson River to the south and the Cache la Poudre River to the north. Both the Big Thompson and the Poudre flow east; we still aren't at the Continental Divide.

But you can *see* the Continental Divide from the Gore Range Overlook, as it follows the mountains on the far side of Forest Canyon to the ridge at the base of the Overlook. Here the Continental Divide splits the Colorado River watershed, which flows west to the Gulf of California, from the Cache la Poudre watershed, which flows east to the Platte River and then the Mississippi River.

The Utes

The Ute Trail continues west down the slope below the Gore Range Overlook. You can still see parts of the trail today, 150 years after the tribes last used them. It takes a long time for the tundra to heal.

The Ute tribe appeared in Colorado between 1100 and 1300, probably coming from the Great Basin in Utah, to the west. This means that Utes have been in the Colorado mountains far longer than any other group—at least seven hundred years.

The Ute territory ranged from west-central New Mexico to Wyoming, onto the High Plains and into central Utah. Some of their favorite summer grounds were the central mountain parks of Colorado.

True to the Utes' Great Basin roots, rabbits were a mainstay of their early diet, with mule deer, elk, pronghorn and bighorn sheep added to the menu when they could get them. The women spent most of their time gathering wild foods. In the spring, they collected sap from ponderosa pine trees to eat as a treat. When food was scarce, the inner bark of the ponderosa pines was scraped off and eaten raw or mixed with other ground foods and anything else they could find.

For hundreds of years, the Utes came over the Ute Trail to cross between the rich summer hunting grounds of Middle Park and the mild winter climate of Estes Park. Before the arrival of horses, they carried their belongings on their backs, or dogs pulled them loaded in A-frame drags called *travois* (pronounced "trav wah").

By 1800, Arapahos and Cheyennes had migrated from Wyoming to the eastern Colorado Plains. They took an instant dislike of the Utes and attacked them whenever they found them. It took the Arapahos just a few years to push the Utes out of Estes Park and claim the region as their own. But the Arapahos left the area before the first settlers moved in by the 1860s.

Alpine Visitor's Center

Elevation 11,796 feet (3,596 meters)

The visitor's center is perched on the edge of the Fall River Glacier cirque, and it is well worth a stop to look down at this bowl-shaped valley behind the building. The cirque was gouged out of the mountain starting 1.8 million years ago as the glacial ice began to move. From here, the ice flowed down Fall River Valley and through Endovalley and Horseshoe Park to the Fall River Park Entrance—8.75 miles (14 kilometers). The glacier ran the length of the valley as recently as fifteen thousand years ago.

It is hard to get a sense of the size of the glaciers and the power that the ice had. As you stand on the rim of the Fall River cirque and look across three-fourths of a mile to the other side and half a mile down, remember that at one time, the entire scooped-out area was filled with ice. And remember that the cirques that you see on other mountains are often as large and sometimes larger.

Winter Storms

In the alpine zone above timberline, winter storms bring the most precipitation of any season. The winds above timberline are at their strongest then, frequently between 50 and 100 miles per hour, sometimes surging to over 200 miles per hour, making these some of the fiercest winds in the world.

Mostly, the moisture brought to the high country by the prevailing "westerlies" falls on the west side of the mountains. But at the very tops of the peaks, where we are now, it gets a little complicated. The west winds still bring water to the west side of the mountains. As the winds funnel up the ever tighter and narrower valleys, they pick up speed and pick up snow.

But the moment that the winds cross the crest of the mountains, they have more room and slow down. When the winds slow down, they drop snow on the *east* side of the crest, sometimes forming lips of snow called "cornices." This only happens at the very tops of the mountains.

This is why glaciers start on the east or northeast sides of the mountains—the prevailing westerlies sweep up snow from the west side and drop the snow on the east. The extra snow helped build up the glaciers.

Fall River Road

Fall River Road, the original dirt road running across the Continental Divide, rejoins Trail Ridge Road at the Alpine Visitor's Center.

Bighorn Sheep

Bighorn sheep are the only large grazers to live in the tundra year-round. They gather on exposed, windblown turfs and fellfields because snow is thinner there, letting them paw through the crust to reach the dormant plants beneath. Few other animals attempt to live in the alpine tundra year-round.

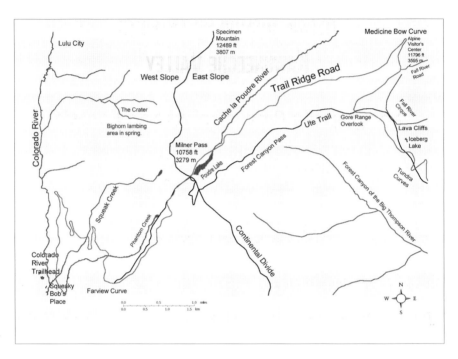

Alpine Visitor's Center to the Colorado River Trailhead. This section of Trail Ridge Road drops 2,800 feet (853 meters) in 11 miles (17.7 kilometers) and crosses the Continental Divide. *Courtesy the author.*

ALPINE VISITOR'S CENTER TO KAWUNEECHE VALLEY

Lodgepole Pine and Aspen Forests

MEDICINE BOW CURVE

Elevation 11,724 feet (3,574 meters)

At Medicine Bow Curve, you can see the Medicine Bow Mountains stretching north into Wyoming. The Cache la Poudre River flows through the valley at the base of the Overlook.

West across the Cache la Poudre Valley is reddish Specimen Mountain, at 12,489 feet (3,807 meters). The volcanoes that built Specimen Mountain were active 27 million years ago; they and Specimen Mountain were probably much higher at that time. Specimen Mountain was named for the many different mineral specimens found in the volcanic rocks.

Except for Specimen Mountain to the west and the Lava Cliffs east of the Alpine Visitor's Center, the mountains from the Colorado River to the Forest Canyon Overlook on Sundance Mountain are made of 1.8-billion-year-old metamorphic schist and gneiss.

At timberline, just below the Overlook, the hurricane-force winds twist and stunt limber pines, Englemann spruce and subalpine fir into gaunt shapes as the trees struggle to survive.

Mountain Ranges

We run into a problem with terminology when we talk about "mountain ranges." What is a "range"? Well, it's a group of mountains, like the Appalachian Mountain Range or the Rocky Mountain Range. But smaller ranges exist within these huge ranges, such as the Front Range within the Rockies. Mountain ranges are defined by geology, rivers and convention. There is no hierarchy of über ranges or rangelettes, and people frequently disagree about a range's exact boundaries—they're not carved in stone.

To add to the confusion, you'll often hear the cities just east of the Front Range of mountains called "the Front Range," as in "the population of the Front Range," few of whom live in the mountains at all.

Rocky Mountain National Park is in the Front Range of mountains, a sub-range of the Rocky Mountains. Within the park are three smaller ranges of the Front Range: the Mummy, the Medicine Bow and the Never Summer Ranges. In addition to those in the park, the Indian Peaks on the southern boundary of Rocky Mountain National Park and the Laramie/Sierra Madre Mountains on the northern boundary are in the Front Range as well.

More Water on the West Slope

The spruce-fir and lodgepole forests on the Western Slope grow taller and denser than their counterparts to the east. That's because the west side of the mountains is much wetter than the east. In fact, 80 percent of all the water that falls on Colorado falls on the Western Slope.

Water, Westerly Winds and Rain Shadows

The extra moisture falls on the Western Slope because westerly winds bring moisture from the Pacific Ocean. As the wet air travels east, the mountains force storm clouds up as upslope storms. To rise, the air drops the water as rain or, more likely, snow. The westerlies are the winds that brought the moisture to make the glaciers. Now, in a warmer, drier climate, they still bring 20 inches of moisture per year, with most of it coming as over 145 inches of snow.

Once over the top, the air is empty of moisture. The east side of the mountains is in a "rain shadow" and is much drier. This is true throughout the Rocky Mountains—in fact, it's true of any mountain range.

Winter and spring storms from the West Coast bring most of western Colorado's moisture, especially in this subalpine community. The snow builds up in level or shaded areas. This is the "snowpack" that provides water for Colorado and downstream states. The amount of snow that builds up determines how much water cities and farms at lower elevations get. Most of the snow melts in May and June. Much of this runoff is diverted to storage reservoirs such as Shadow Mountain and Granby Reservoirs and sent to lower, more populated areas along the Front Range.

Yellowish Ash in Road Cuts

As you drive this section of Trail Ridge Road, you can see yellowish ash in road cuts. The ash is from explosions of the Never Summer volcanoes 27 million years ago.

Poudre Lake, Milner Pass and the Continental Divide

Elevation 10,758 feet (3,279 meters)

The highway drops about 1,000 feet (305 meters) in four and a half miles from the Alpine Visitor's Center to Milner Pass, so the pass, on the Continental Divide, seems as if it is much lower than 10,758 feet.

Poudre Lake

This lake's name comes from the Cache la Poudre River, which starts here and flows north into the Cache la Poudre Wilderness and then east to the plains. The Cache la Poudre River was named when, in 1836, a group of French Canadian trappers had to hide (*cache*) some black power (*poudre*) where the river comes out of the mountains and onto the plains. In total disregard for any French diction, the word is locally pronounced "pooder."

Milner Pass and the Continental Divide

Finally, we reach the Continental Divide! Milner Pass is the divide between the headwaters of the Cache la Poudre River, which flows east, ultimately to the Mississippi, and those of the mighty Colorado River, which flows west. The Arapahos called Milner Pass "Deer Pass."

The Ute Trail rejoins the highway from the steep shortcut it took down from the Gore Range Overlook, up and to the east. Both then wind their way down to the Kawuneeche Valley.

Bighorn sheep congregate to lamb on Specimen Mountain, to the west. Males often spar for dominance.

Farview Curve

Elevation 10,275 feet (3,132 meters)

Farview Curve does indeed allow for far views.

Never Summer Range

Across the Kawuneeche Valley, the Never Summer Range rises to over 12,000 feet (3,658 meters). The Never Summer Mountains were built by a combination of uplift and volcanoes.

As the Rocky Mountains rose 72 to 6 million years ago, the Never Summer Fault cracked beneath the Kawuneeche Valley. The fault shoved ancient 1.8- to 1.4-billion-year-old igneous granite and metamorphic gneiss and schist rocks to the west.

The Never Summer Fault weakened the crust, and as the mountains continued to rise, new volcanic magma was pushed to the surface. The base of the Never Summers is the granite remnant of cooled volcanic magma chambers.

When the volcanoes reached the surface 29 to 24 million years ago, they spewed out lava and ash, which covered the area. Cone-shaped Red Mountain, standing a little in front of the rest of the Never Summers, was one of the volcanoes responsible for the eruptions. Eruptions of

Red Mountain produced the volcanic rocks at Lava Cliffs and Specimen Mountain, as well as the tops of the northern Never Summers. By the time the eruptions were spent, the Never Summer Mountains were thousands of feet higher than they are today. Iron oxide (rust) in the volcanic rocks colors them red or yellow.

From 1.8 million to 10,000 years ago, the Kawuneeche glacier took advantage of the Never Summer Fault and plowed the Kawuneeche Valley steeper, deeper and straighter. In doing so, the glaciers stripped away most of the ash and lava left by the volcanoes.

The Kawuneeche glacier was more than 2,000 feet (610 meters) deep, the deepest in the national park. At 20 miles (32 kilometers), it was also the longest glacier in the park, stretching south beyond the park boundaries. The Kawuneeche glacier's lateral moraine dammed several creeks to create Grand Lake, and its terminal moraine created the islands near the south shore of Shadow Mountain Reservoir.

Lulu City and Mining

Three miles to the north, at the head of the Kawuneeche Valley, was the small mining town of Lulu City. Mining was never very important in this part of the Colorado Rocky Mountains. Although there were a few mines in what became Rocky Mountain National Park, this area is not in the Colorado Mineral Belt, which ran from the San Juan Mountains in southwestern Colorado through the Mosquito Range to the Front Range above Boulder. Being off the Mineral Belt means that this region doesn't have the fabulously rich veins of precious metals of Leadville, Silverton or Central City. The ore from the mines at Lulu City wasn't worth packing over Berthoud Pass to Denver to be processed. And so the town didn't last long.

The lack of mineral wealth meant that settlement was lighter and slower here. Aside from the scattered mines that struggled to produce, a few ranchers homesteaded in the area and a few loggers cut timber. But it soon became obvious that the real value of the high mountains was their beauty. Tourists came to the area starting in the 1870s and were willing to pay others for a place to stay. The recreation industry in Colorado was born.

Above Lulu City is Thunder Pass, named by the Arapahos for the thunderstorms that seemed to constantly hang over it.

Thunderstorms

Frequent thunderstorms in the mountains make lightning strikes common, such as the strike that hit this tree. Get under cover when a thunderstorm develops. *Courtesy the author.*

Mountains generate summer thunderstorms most often during the last half of July and all of August, but they are possible even in June. Above timberline is an especially bad place to be in a thunderstorm, as is under a lone tree. Avoid exposed ridges during stormy periods; the burned treetops testify that lightning strikes there often.

In a lightning storm, the best place to take shelter is inside the cover of a building. Your car is a very safe place to be, as long as it has a hard roof. Motorcycles or open-top vehicles like convertibles and tractors are dangerous even with the top up, as the fabric doesn't protect against lightning. If you are hiking in the high country, get below timberline, under a canopy of many trees rather than just one.

Contrary to the old saying, lightning actually prefers to strike the same place twice if that place is some sort of electrical attractor: it is the tallest thing around, it's metal or it's in the water. Don't be in any of those places during a thunderstorm.

The Mighty Colorado River

The beginning of what will become the mighty Colorado River meanders at the bottom of the valley. The Colorado River headwaters are near La Poudre

Pass, to the north, above Lulu City. The Colorado is the most important river in the American Southwest. Its waters are responsible for the incredible agricultural success of Arizona and central and Southern California.

Here, the Colorado River is still small. With excess energy from its fall down the mountain slopes, the river meanders sideways across the flat valley floor instead of cutting down. Sometimes the loops cut themselves off, creating oxbow or horseshoe lakes.

The Grand Ditch

Across the valley, you can see a horizontal line running across the steep sides of the Never Summer Mountains. This is the Grand Ditch, dug by hand through solid rock at 10,000 feet (3,048 meters) by Americans and Japanese immigrants from 1890 to 1932.

In the 1880s, most people still thought of land—all land—in terms of how they could make a living from it. The area that now makes up Rocky Mountain National Park produced timber, a few minerals and that most precious commodity in the West: water.

Before 1921, the Colorado River was known as the Grand River. It was recognized even then that moving Grand River water to the Front Range would provide irrigation water for thousands of acres of farmland. And so the Grand (River) Ditch was begun.

The Grand Ditch was designed to catch meltwater from the spruce-fir forest above and redirect it to a reservoir. Twenty feet wide by six feet deep, the Grand Ditch catches thirty-five thousand acre-feet of Colorado River water annually—enough for 136,000 households—and diverts it to the Front Range over La Poudre Pass. The water then flows down the Cache la Poudre River. Because an irrigation company owns it, the water is used to irrigate farm fields on the plains.

But on May 30, 2003, the Grand Ditch breached its bank above the old Lulu City townsite. The breach released an estimated one hundred cubic feet per second down the slope. The water washed a mile and a half down the steep hillside and loosed a massive slide of mud, trees and rock into Lulu Creek and the headwaters of the Colorado River. More than twenty thousand trees were destroyed, and the Lulu City wetlands were damaged.

In 2008, an out-of-court settlement was reached in which the owners of the Grand Ditch agreed to pay the National Park Service $9 million in damages. In 2014, Rocky Mountain National Park decided on a plan to

Stone cairns like this one were originally built by Utes and Arapahos to mark the trail. This one has a "modern" marker on top. *Courtesy United States Geological Survey.*

clean up the mess. Researchers are studying why the breach happened and how they can repair the damage.

Cairns in the Forest

The Utes and Arapahos used piles of stones, called "cairns," to mark the trails through the spruce-fir forests. They always passed on the same side of a cairn and always added a stone when they passed by.

Lodgepole Pine, Quaking Aspen and Mountain Pine Beetles

Although Farview Curve is still in the spruce-fir forest, as you look down the valley you can see the remnants of the lodgepole pine forest that once dominated the Kawuneeche Valley and the quaking aspen that are coming in to replace it.

Lodgepole pine and quaking aspen are both trees that appear where there has been a severe disturbance in the existing plant community. Disturbances might be something like a forest fire, an avalanche, a mining or a logging

operation or an insect epidemic. The harsh, intense sunlight and the bare, dry soils that kill the seedlings of most other mountain trees are perfect for quaking aspen and lodgepole pine to thrive.

Lodgepole Pine

In Rocky Mountain National Park, lodgepole pine forests are common on both sides of the Continental Divide from 8,500 to 9,000 feet (2,591 to 2,743 meters), often starting on bare, rocky soil. They like a cool and dry climate, with a short growing season.

Lodgepoles grow in very dense forests of tall, straight, thin trees called "doghair" stands. Plains tribes used the logs for their tepee or "lodge" poles. Dense as the forest is, little light reaches the lodgepole pine forest floor. Not much grows under lodgepoles. And so, not many animals live in a lodgepole forest. Pine squirrels ("chickarees") collect the lodgepole cones, eating the seeds and dropping the woody scales in piles below called "middens." Pine martens and Sharp-shinned Hawks feed on pine squirrels. Woodpeckers eat insects that burrow under the bark of the trees. Occasionally, larger animals

Dense "doghair" stands of lodgepole pine cover the mountains from Colorado to Canada. Compare the barren understory to that of an aspen stand. *Courtesy the author.*

may pass through a lodgepole forest, but they can't make a living from the few plants that survive in the dark forest floor and so they move on.

More than any other species of tree in Colorado, lodgepoles need fire to survive. Forest fires burn understory and dead trees. This clears a space for the lodgepole seedlings—which love sun and bare earth—to grow.

Before the seeds sprout, though, they must be released from their cones. Lodgepole cones are glued shut by resin, or pitch. The cones are "serotinous"—they need high temperatures of fires or hot days to melt the resin between the scales and allow the cones to open up.

These densely growing pines are susceptible to disease and insect attack. Today, the pine forests are red-orange to brown instead of their normal evergreen. The dead trees you see on the mountain slopes are lodgepole pine trees that were killed from 1996 to 2013 in a massive mountain pine beetle epidemic.

Mountain Pine Beetles

Mountain pine beetles are hidden for almost all of their lives. These black, rice-sized insects emerge late every summer from the tree in which they hatched and fly to a new tree to lay their eggs. They bore through the hard outer bark and into the soft inner bark of the tree. The tree tries to "cast them out" by flooding the tunnels with pitch. In young, healthy trees, this often works, if there aren't too many beetles. In older pine trees, though, the mountain pine beetle usually gains a toehold under the thick bark of the trees.

Once in the tree, mountain pine beetles bore through the soft tissue under the bark, leaving tunnels in the living tissue between the bark and the wood. This is where the insects mate and lay their eggs. The inner bark is where the tree moves water and nutrients up and sugars and starches down. When too much of the inner bark is destroyed, the tree dies. If too many beetles chew too many tunnels, they can kill the tree.

More often, however, the trees die from a fungus that the beetles carry on their bodies. The fungus infects the trees and continues the work that the beetles began, pushing root-like filaments through the tree until they have "girdled" it (killed it by cutting tunnels through the living part of the tree underneath the bark). The fungus leaves behind an easily identifiable blue stain in the wood.

There are always mountain pine beetles in lodgepole pine forests, as they are a natural part of the ecosystem. In true predator fashion, in a healthy

forest, low numbers of beetles kill trees that are weak or sick. Young, healthy trees can cast them out. The thick bark of older trees actually protects the beetles, making trees older than about five years more vulnerable to attack.

Because mountain pine beetles live under the bark, they aren't killed by spraying the trees with insecticide. Once tucked into an older tree with thick, insulating bark, it takes five days of -30°F (-34.4°C) weather to kill the beetles. The Colorado mountains didn't get the required cold snap to stop this epidemic of beetles. Instead, the beetles just ran out of trees to eat.

For the past thirty-five years or so, people have been beating themselves up about the fact that we used to put fires out as soon as we could, creating unnaturally dense, sickly forests. That policy changed in the 1980s, but it was assumed that fire suppression created overly dense lodgepole pine forests and contributed to the mountain pine beetle epidemic.

But new science is suggesting that the crowded lodgepole forests, and the resulting mountain pine beetle epidemic, may be completely natural. Lodgepole forests along the Front Range of Colorado have fires about every 100 to 400 years; we only suppressed fire in forests for about 60 to 70 years, so humans didn't necessarily influence the forest that much. This beetle infestation, while the largest in *recorded* history, may not be unusual if we look back more than the 150 years that people have been writing about western forests. For now, the mountain pine beetle epidemic has burned itself out. In the meantime, research continues.

The dead lodgepoles will be replaced first by wildflowers and grasses. But quaking aspen will be the big winners for centuries to come. The rejuvenated understory will enable more deer and elk to thrive where the old lodgepole forests stood.

While the other plants are enjoying a burst of life in the newly opened forests, the young lodgepole that escaped the epidemic will be growing as well. In two hundred years, lodgepoles will be the dominant trees in this area again. Lodgepoles will be back.

Quaking Aspen

The tree that will benefit the most from the death of the lodgepole pines is quaking aspen. Even now, light green–leafed quaking aspen are sending up suckers into the vacant forest landscape.

In Colorado, aspen groves are common from the middle to high elevations (8,000 to 10,000 feet or 2,438 to 3,048 meters). Light-green aspen leaves

allow light to reach the forest floor, and this allows understory plants to thrive. Because aspen groves can support a lush understory, many small rodents and their predators are common. Mule deer and some elk use the aspen groves. Moose, beaver, porcupine, black bears and other animals browse on leaves, twigs and bark of aspen. As the aspen come in, the number of animals will increase to more than in the lodgepole forest.

In fall, aspen are famed for their brilliant yellow and orange colors. As they fill in the forest, these slopes will be ablaze with color.

Final Hairpin Curve

This is as far up the west side of Trail Ridge Road as you can go in winter; there are gates here to close the highway when the snows come.

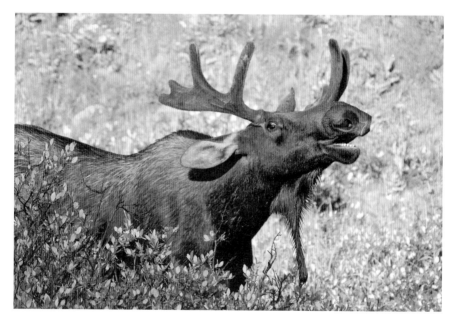

The look of an angry moose just before it charges. Don't be the reason a moose gets this look. *Courtesy Dick Vogel.*

Moose

Moose have been reintroduced into Colorado. If you're lucky, you might see some in here, as well as beaver and mule deer. Elk don't gather in the Kawuneeche Valley during autumn rut in the huge numbers that they do in Moraine and Horseshoe Parks on the east side of the Continental Divide, but you still might see or hear them.

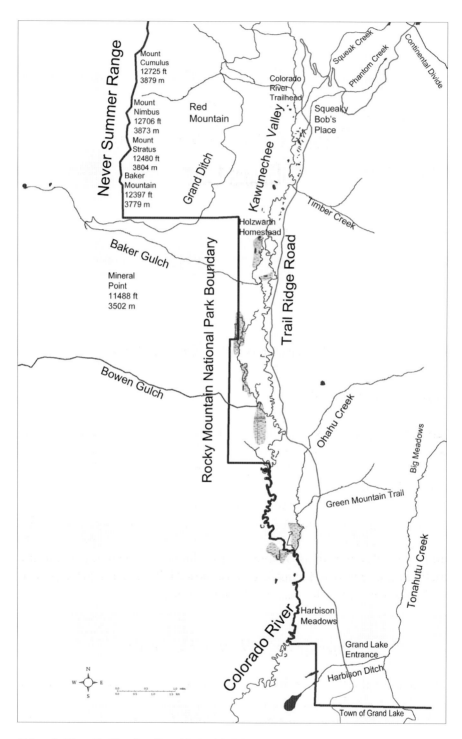

Colorado River Trailhead to Grand Lake. Trail Ridge Road follows the Colorado River from its headwaters to Grand Lake. *Courtesy the author.*

Chapter 6

Colorado River Trailhead to Grand Lake

Valley Floor

Colorado River Trailhead

Elevation 9,027 feet (2,752 meters)

The highway reaches the Kawuneeche Valley floor, more than 1,000 feet (305 meters) lower than Farview Curve, four miles back. The name Kawuneeche comes from the Arapaho words *koo' oh* ("wolf" or "coyote") and *neéchee* ("chief").

The Colorado River follows the Kawuneeche Valley. The valley, in turn, follows the Never Summer fault zone, created as the mountains broke through the surface. The Never Summer Mountains here didn't get caught up in the volcanic activity of those just to the north. These mountains are metamorphic gneiss and schist, created almost 2 billion years ago but pushed to the surface only in the last 72 to 6 million years.

Squeaky Bob's Hotel de Hardscrabble

Just south of the Colorado River Trailhead was Robert Lincoln "Squeaky Bob" Wheeler's "Hotel de Hardscrabble."

Squeaky Bob came to his brother's North Park ranch in 1885, at the age of twenty. Bob got his nickname because his voice rose in pitch when he was excited.

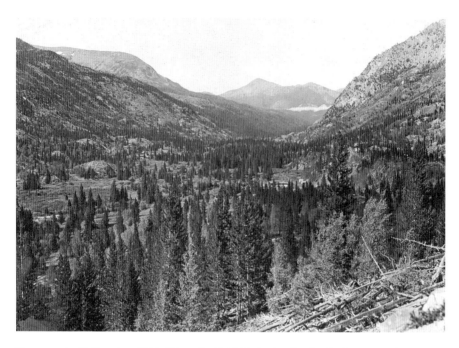

Kawuneeche Valley, circa 1919. "Squeaky Bob's" is in the clearing in the center of the photograph. *Courtesy United States Geological Survey.*

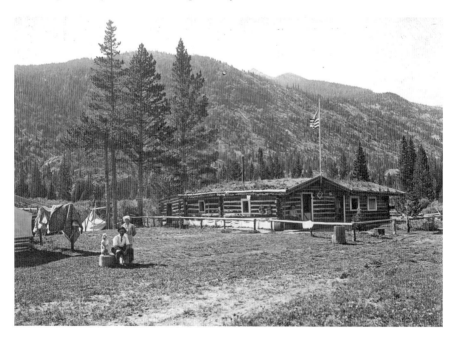

"Squeaky Bob" Wheeler, his housekeeper and his dog in front of his "Hotel de Hardscrabble," circa 1919. *Courtesy United States Geological Survey.*

Wheeler volunteered in the Spanish-American War in 1898. Although the story is often told that Wheeler rode with Theodore Roosevelt and the Rough Riders, it seems that instead he took care of the Rough Riders' horses, and his troop never actually made it out of Florida.

Squeaky Bob returned to Colorado to homestead on the North Fork of the Grand River in 1907. He first called his tent-house resort Camp Wheeler and then Hotel de Hardscrabble, but everybody else just called it "Squeaky Bob's." The place was only renamed Phantom Valley Ranch after Bob sold it in 1924.

Shep Husted, a mountain guide, brought people over either the Ute Trail or the Fall River Trail from Estes Park to stay at Hotel de Hardscrabble. Bob's guests included eastern high rollers and aristocratic English groups eager to hunt and fish. Squeaky Bob's was famous for two things: his biscuits, which Teddy Roosevelt loved, and the rumor that he never changed the sheets on his camp beds.

Bob married Allie Farquher and then ran Hotel de Hardscrabble with her until 1924, when they moved to Denver due to his heart trouble. He died in 1945.

Holzwarth Trout Lodge

Elevation 8,806 feet (2,684 meters)

John Holzwarth was an emigrant from Germany. In 1870, he homesteaded a place south of Grand Lake for ten years and then sold it and moved to Denver. In 1916, John, his wife, Sophia, and their family moved back to the Kawuneeche Valley. They ran cattle, grew hay, trapped and had a timber sawmill.

In 1919, as friends came to visit, hunt and fish, the Holzwarths developed their Trout Lodge. Fall River Road opened in 1920, carrying people from Estes Park all the way to Grand Lake for the first time. When John died on Christmas Day 1932, his son, Johnny, took over running the Trout Lodge.

In 1933, Trail Ridge Road opened, bringing more vacationers. The Holzwarths responded by building the Never Summer Ranch for guests. For forty years, the Holzwarths created memories that former guests cherish to this day.

The Holzwarths sold their property to the Nature Conservancy in 1973; the Nature Conservancy sold the place to the National Park Service in 1974.

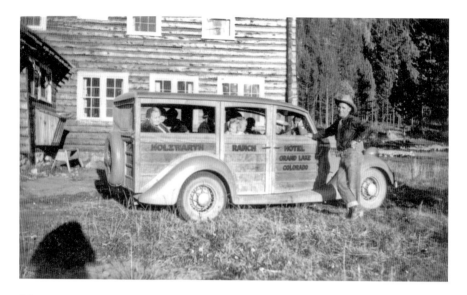

Johnny Holzwarth at the Never Summer Ranch, circa 1935. The building in the photo was torn down by the National Park Service in the 1970s. *Courtesy National Park Service.*

The Park Service tore down the Never Summer Ranch a few years later. They kept the older "Mama" Cabin and buildings of the Trout Lodge. Today, the "Mama" Cabin is open for visitors to enjoy.

Streamside Plant Community

By definition, "riparian" or streamside communities get much more water than do the steep slopes around them. The extra water means that many more "deciduous" (plants that drop their leaves in fall) trees and shrubs grow along their banks than elsewhere. Along streams throughout the mountains, you can see a riparian community of alder, narrowleaf cottonwood, birch, willow and coniferous blue spruce almost the entire range of elevations.

Riparian communities thread their way up the mountains from the plains (5,600 feet or 1,707 meters) to timberline (11,500 feet or 3,505 meters), like green thread through fabric, tying other communities together. The community changes as it goes up, with snow- and cold-tolerant plants coming in as those that need more heat and light recede, creating a mosaic of plants.

Not only do streamside communities change with altitude, they also change with time. Floods form new channels and wash away stream banks but leave layers of rock and muck behind. Sticks slow flowing waters, and

Streamside plants like these winter-bare willows line the Colorado River. *Courtesy Randall Law.*

roots choke channels. Beaver dam swift streams and turn them into quiet ponds. Plants grow and die, adding their dead plant material to the soil particles that get caught in still water. Slowly the ponds fill up.

The abundant food and cover of riparian communities draw animals to them. Waterfowl need the wetlands for nesting, and muskrat, river otter, moose and many other animals require them for food and shelter. This is where you may see beaver or, more likely, their stick dams and houses. Many animals, including humans, use the riparian community as a migration route between winter grounds and summer areas.

One of the unsung features of the riparian community is that it filters the water flowing through it. Healthy riparian communities clean water better and cheaper than man-made water treatment plants. Where riparian communities have burned, and the water cleaning plants have been lost, water quality has suffered.

The Arapahos

As late as 1673, the Arapahos lived on the banks of the Great Lakes in Minnesota. They were pushed out of the Great Lakes and Northern Plains by the Ojibwas and Lakotas. But then, in the prairie west of the Black Hills, the Arapahos rejoined their old friends, the Cheyennes, to ride the plains and hunt buffalo.

Soon, the two tribes split into northern and southern groups. The northern group lived west of the Black Hills, and the southern group ranged between the South Platte and the Arkansas Rivers in central Colorado.

By the 1800s, the northern Arapahos were expanding into the Colorado mountains. At first, they came to get lodge poles for their tepees from lodgepole pine in Kawuneeche Valley. Gradually, they spent more and more time in the mountains. By the time whites came to the state, the Arapahos considered Estes Park and the surrounding area to be theirs and were pressing the Utes for possession of North, Middle and South Parks. But by the early 1860s, the Arapahos had left the high country, well before they came into conflict with the white settlers flooding into the mountains looking for gold and silver. By 1878, the northern Arapahos were confined to the Wind River Reservation in Wyoming.

Fifty years later, in 1914, the momentum to make part of the northern Colorado Mountains into a national park gained strength and speed. To continue to build interest, a group of park proponents asked two northern Arapaho elders who had lived in the area to come back and put names to many of the features in the park. For two weeks, the Arapahos rode the area, telling stories of their youth. Finally, although there were more stories to tell, the elders were tired and wanted to return to their homes and families. The names of many of the features you see in Rocky Mountain National Park today are reminders of this trip.

Bowen-Baker Gulch

Elevation 8,800 feet (2,682 meters)

To the west, at the southern end of the Never Summer Range, is Bowen-Baker Gulch. This "gulch" is, in reality, a U-shaped, glacially carved valley that fed into the Kawuneeche glacier during the Ice Age.

On Baker Mountain on the north side of the gulch, you can see a line in the forest. This is the start of the Grand Ditch, which cuts across the slopes of the Never Summer Range all the way to La Poudre Pass, above Lulu City. This ditch diverts water to Long Draw Reservoir, for use on the Front Range.

Onahu Creek

Onahu Creek was named by the Arapahos after a horse that died there. The horse was called *Ónah hú* ("Warms Himself") because he used to warm himself by standing close to the fire.

Harbison Ranch

Annie and Kitty Harbison came to Grand Lake with their parents and younger brother in 1896. The sisters each claimed 160 acres to homestead, side by side, so that their combined acreage was 320 acres—just enough to run twenty-five to thirty dairy cows to satisfy the milk demands of nearby Grand Lake. The meadow that spreads out to the south of Harbison Picnic Area was their ranch.

The Harbison sisters, with their dog, Scout, in front of their cabin. The cabin sat where the Kawuneeche Visitor's Center is now. *Courtesy National Park Service.*

Their older brother, Harry Harbison, along with his wife and son, homesteaded at Columbine Lake in 1891. Harry built a commercial trout farm to supply restaurants with fresh rainbow trout. He had a problem, though. His small fry (little fish) kept dying because there wasn't enough oxygen or nutrients in the spring water he was using for his fishponds. He needed creek water. To fix the problem, Harry dug a shallow ditch from Tonahutu Creek to Columbine Lake by hand—a distance of about a mile and a half. It took him several summers to get the job done. His sisters built their homestead next to this canal and had fresh running water, summer and winter. Today, the Kawuneeche Visitor's Center, built on the site of the Harbison sisters' cabins, has a pleasant creek that runs between the buildings—the Harbison Ditch.

The dairy farm gave the Harbison sisters a living. They ran the place, while their younger brother, Rob, made the deliveries. He'd take a wagon down to Grand Lake and make his rounds and then get in a boat and row across the lake to deliver milk to folks on the south shore.

Rocky Mountain National Park was established in 1915. The Harbison sisters were not pleased to have grazing banned in the park; they saw it as a threat to their livelihood. By the 1930s, the National Park was asking the sisters to sell a corner of their land so that the Park Service could relocate the road up the Kawuneeche Valley. For a long time, the sisters refused, but in 1938, they were ready to sell the corner. They agreed to a price with the Park Service. But in November, before the contract could be completed, both Harbison sisters, then in their sixties, contracted pneumonia. They died within a week of each other.

The sisters left their ranch to Mary Schnoor, whom they had adopted as a young girl when her mother died. Mary completed the sale of the corner lot that the sisters had started. The remainder of the ranch was sold to the Park Service in 1954.

In the 1970s, the Park Service removed the Harbison dairy ranch buildings and replaced them with the Kawuneeche Visitor's Center.

Grand Lake Park Entrance

Elevation 8,524 feet (2,598 meters)

Just before the national park entrance, the Tonahutu trailhead heads into the forest to the east. *Tonalhúta* means "Big Meadow" in Arapaho.

The Town of Grand Lake

Elevation 8,367 feet (2,550 meters)

The town of Grand Lake started as a supply center for the few mining camps that sprang up in the area. One-armed explorer and scientist John Wesley Powell and William N. Byers, founder of the now defunct *Rocky Mountain News*, outfitted at Grand Lake in 1868 to climb Longs Peak. They were the first recorded group to climb the peak, but they had heard reports that Old Gun, an Arapaho, had an eagle trap on top. The Arapahos said that Old Gun climbed Longs at night so the eagles wouldn't see him.

After climbing Longs, Powell set off down the Colorado River, the last unexplored area of the continental United States. He returned with a vast amount of information that continues to influence water policy in the western United States today.

The weather here is cold and snowy, as befits a high mountain town. Between 80 and 140 inches of snow falls in Grand Lake on average. Combined with rainfall, Grand Lake gets between 14 and 20 inches of moisture, a little more than is average for Colorado.

Grand Lake

Grand Lake is the largest and deepest natural lake in the state. The lateral moraine of the Kawuneeche Valley glacier and the terminal moraine of the Paradise Creek glacier dammed the headwaters of the Colorado River to make the lake.

Deer, elk, muskrats and waterfowl of every sort all frequent Grand Lake's shores. If you're lucky, you might see a Bald Eagle skimming across the surface of the lake, catching its dinner.

The Arapahos called Grand Lake "Big Lake" or "Spirit Lake" for the spirit of a huge buffalo that lived in the lake. The Utes also call Grand Lake "Spirit Lake," but for a different reason. They tell of a big battle with the Arapahos at the lake. Before the battle, the Ute women and children built a raft and paddled to the middle of the lake for safety. A big storm came up, and all the women and children were drowned. After that, the Utes avoided the lake. Oddly, while the Arapahos remember fighting the Utes by the lake, they remembered Ute casualties to be small.

Chapter 7
GEOLOGY

Mountains are all about rocks—thrust up and worn away, carved up and pushed around. But the mountains make geology relatively simple. You have just a few events you have to remember. Before the current mountains rose, there were two continental plate collisions that created three of the types of rock that you see in Rocky Mountain National Park. The rise of the Rockies created a fourth type of rock. And the cutting by the fifth type of rock put the final touches on the landscape that you see.

The types of rock to learn? Schist, gneiss, granite, rhyolite and ice.

THE FIRST ROCKS: GNEISS, SCHIST AND GRANITE

About 2 billion years ago, just as life was getting started on the planet, Colorado was covered in oceans, with only a few islands above the water's surface. Deep layers of mud collected on the ocean floor and sand on the beaches. As the layers of sediments built up, heat and pressure packed the individual grains of these minerals together into sedimentary shale and sandstone. But these minor players weren't around for long.

Metamorphic gneiss is created when sandstone is pushed deep into Earth's crust. Heat and pressure collapse the grains into layers or bands. *Courtesy the author.*

Gneiss

After a few hundred million years, two tectonic plates collided, forcing much of the existing Colorado sandstone and shale deep into Earth's crust. The heat closer to the molten mantle and the pressure of a continent pressing down on the minerals was so great that it squashed individual molecules into new shapes. Remember that a diamond is just charcoal that has been subjected to this mind-boggling heat and pressure.

Being forced deep under the continent, the sandstone turned into gneiss (pronounced "nice"), identifiable by its light and dark bands. Gneiss has large crystals in layers. These layers are often bent and warped—it's obvious that at one time these rocks were as plastic as Play-Doh. Gneiss is usually striped or banded black and white.

Schist

The same heat and pressure converted shale to another hard mineral called schist. Schist is often made up of light gray quartz; pink, green and gray

Metamorphic schist is made when clay or slate are pushed deep into Earth's crust. Hornblend and biotite (mica) make schist shiny. *Courtesy the author.*

feldspar; dark hornblend (a dark, sparkly silica mineral); and biotite (a type of mica). These last two minerals make schist shiny. In fact, geologists use the phrase "banded gneiss and shiny schist" to tell the two types of metamorphic rock apart. They are both very old, very hard rocks.

By the way, any puns you think of on the names of these two rock types are very old jokes and are no longer funny. Really. Don't bother.

Granite: A Short Time Later (Geologically Speaking)

In another ancient continental collision 1.4 billion years ago, South America crashed into North America. The metamorphic schist and gneiss were still deep underground and continued to warp, wrinkle, bend and twist. This impact also forced scattered masses of igneous granite magma into the existing metamorphic rocks underneath Rocky Mountain National Park.

Granite is made up of pink, gray and green feldspar; glassy white quartz; and dark mica (biotite), with maybe a little hornblend (a dark, sparkly silica

Igneous granite is made when glassy white quartz; pink, gray and green feldspar; and dark mica (biotite) melt and then cool into interlocking crystals. *Courtesy the author.*

mineral). Rather like a poorly mixed cake, granites intruding at the same time can have a variety of colors: gray, dark red, pink or black-and-white. You'll see both gray and orange granite in Rocky Mountain National Park.

Molten granite cools slowly underground. Slow cooling allows the granite to form large interlocking crystals. In the big crystals of granite, the mica absorbs water. Water expands by about 9 percent when it freezes into ice. That means that as the water repeatedly expands and shrinks in freeze/thaw cycles, it shatters the mica crystals and pops quartz and feldspar crystals off the rock. This takes the sharp edges off granite boulders. Sheets of granite will also fracture off as the pressure above it is released, giving large rocks a layered look. These two actions slowly round off granite outcrops and boulders.

The Twin Owls in Lumpy Ridge near Estes Park and Bighorn and MacGregor Mountains along Horseshoe Park are good examples of granite outcrops weathering into smooth domes.

A Gap in the Geologic Record

After the collision with South America 1.4 billion years ago, there is a huge gap in the geologic record. Within Rocky Mountain National Park, all of the rocks that were formed over the last 1.3 billion years wore away when the Rocky Mountains were thrust up 72 million years ago.

RISE OF THE ROCKY MOUNTAINS: RHYOLITE

Mountains are made in two ways: Earth's tectonic plates crashing into one another and making crumple zones, or by volcanoes spewing out lava and ash. There are both types of mountains in Rocky Mountain National Park.

Continental Collisions

About 75 million years ago, as the last dinosaurs walked the Earth, the slow-motion ripples of the collision of the Pacific tectonic plate into the North American plate began on the West Coast. About 3 million years later, the ripples finally reached Colorado. Like the hood of a car hitting a wall, the North American plate crumpled into mountains and valleys. The impact broke, bent and folded Earth's crust into many of the mountain ranges we have in Colorado today. The energy of the impact also melted pools of magma deep beneath the rising Rockies.

Fault-Block Mountains

When tectonic plates crash into one another, they make geologic faults that run parallel. If the faults go deep enough, they create "fault blocks." Think of the blocks as a set of books. All the books can move independently of one another, pushed in or pulled out depending on which ones are being used. Fault blocks move in just the same way as the books. When tectonic plates squeeze together, they push blocks up to form fault-block mountains.

The fault-block mountains began to rise 72 million years ago. The mountains pushed up only slightly faster than they eroded, so that by the

end of the uplift, 6 million years ago, the Rockies were gentle hills 8,000 to 9,000 feet (2,438 to 2,743 meters) high, with flat granite, schist or gneiss tops.

The rising land gave streams more energy to cut into the mountains. Eroding rocks added grit to help cut valleys. As the land rose, it stretched, cracked and faulted. Aided by the faults and cracks, streams cut deep canyons. Forest Canyon and the Kawuneeche Valley are straight because the upper Big Thompson and Colorado Rivers follow major fault zones.

Volcanic Flows

The tectonic collision formed pools of igneous granite magma deep below the Kawuneeche Valley. Faults from the collision allowed magma to work its way up. Most of the magma cooled to make the granite bases of the Never Summer Mountains.

Rhyolite and granite have the same mineral composition. The big difference between the two types of rock is that rhyolite comes out of a volcano as a type of lava and cools quickly on the surface. When rhyolite cools quickly, its crystals have no time to grow and so remain small. When rhyolite cools *very* quickly, it forms obsidian, or volcanic glass.

Rhyolite also has the habit of plugging up its magma vent and causing its volcano to explode. Starting 29 million years ago, Red Mountain of western Rocky Mountain National Park repeatedly exploded when rhyolite lava blocked its magma vent. The explosions threw massive amounts of minute molten magma droplets, misleadingly called "ash," into the air. The ash flowed down the sides of the volcano as a cloud of white-hot dust that welded together when it came to rest. The small ash particles hardened into rock that now forms the Lava Cliffs. In fact, the ash at the Lava Cliffs cooled so quickly that tiny bits of brown and black obsidian glass formed in it.

The Never Summer Range and Specimen Mountain were also covered by volcanic rhyolite lava and ash. These mountains were several thousand feet higher than they are now.

Today, we have no active volcanoes in Rocky Mountain National Park. The volcanoes in Rocky last vented 24 million years ago.

Finishing Touches: Ice

Scientists don't understand why, but Earth's climate cooled 2 to 1.8 million years ago. In the high rolling hills of Colorado, snows fell in the winter and didn't completely melt in the summer. Eventually, the ice built up to a point that it began to slide down the valleys as glaciers, carving up the landscape. The Ice Age had begun.

Glaciers

The definition of a glacier is a moving body of ice formed by years of snow accumulation. If the snow and ice just remain from year to year, it is an ice field. The ice has to move for it to be a glacier.

To make a glacier, you need two things, and oddly, neither of them is colder winters. First, you need plenty of snow, and second, you need for it to not melt off through the summer. This usually happens with a combination of lots of snow and cool summers.

During the Ice Age 1.8 million to 10,000 years ago, ice sheets covered much of Greenland, Iceland, England and Scandinavia but less of Russia than you might think. Antarctica, South America and New Zealand had ice caps as well. In North America, vast ice caps covered Canada and Alaska and, at their maximum, pushed into South Dakota, Minnesota, Wisconsin and Illinois, where glaciers gouged out the Great Lakes. The Colorado plains were never glaciated, but in the Rocky Mountains, glaciers formed as far south as the San Juan Mountains in southern Colorado.

Three Glacial Events during the Ice Age

During the Ice Age, Colorado was buried under at least three major glacial events. We don't know much about the oldest glaciation because its deposits have been mixed up by the two after it. But it obviously happened before the middle event, the "Bull Lake" Glaciation, which peaked about 150,000 to 130,000 years ago. This second glaciation was the most severe because it almost completely erased evidence of the first, but it survived the third. The youngest event, the "Pinedale" Glaciation, was only 300,000 to 10,000 years ago; it was at its largest from 23,500 to 21,000 years ago.

Melted in Between Glacial Periods

We know that during the cold periods of the Ice Age, lots of snow fell. Enough snow fell throughout most of the Colorado Rockies to build up glaciers almost half a mile deep, eight to twenty miles long and stretching down to 8,000 feet (2,438 meters) in elevation.

In between the cold spells of the Ice Age, all the ice melted, often in the space of a generation or two. Torrents of glacial meltwater plunged down Ice Age streams.

Glacial Cuttings

In many respects, we live in a glacially formed landscape. Cubic miles of ice weigh enough to literally press the land around it down—Earth is still rebounding from the glaciers of twelve thousand years ago. Because of their tremendous weight, their movement and their constant renewal by snow and ice above, glaciers carve through the hardest rocks. Beginning at steep-walled cirques, glaciers widen, straighten and deepen mountain valleys into a *U* shape, leaving behind moraines and meandering rivers.

When a stream cuts into a mountain, the resulting valley is usually a *V* shape. Glaciers originally followed the V-shaped stream-cut valleys. But there is nothing subtle about glaciers. As they move downstream, glaciers widen, deepen and straighten the valleys. Glaciers also make the valley's side walls steeper, creating a U-shaped valley. When you see a U-shaped valley in the high country, think glacier.

You can tell that glaciers carved the many high mountain valleys because of their steep-walled *U* shape, as well as the straightness of the valleys themselves. On the high peaks around you, you also can see a number of unique glacial features. A "cirque" is a bowl-shaped basin, carved at the head of a glacier high up on the mountain slope. Often it still has a small snow or ice field above it where the glacier started. If the cirque is filled with water, it is called a "tarn."

As the main glaciers carved out a valley, they sometimes cut off smaller glaciers whose ice fed into them to form hanging valleys high above the main river of ice. When the ice melted, streams draining these smaller valleys often plunged over the side to the valley bottom below. These are called "hanging waterfalls."

Glacial Deposits

Cubic miles of glacial ice act as giant bulldozers, ploughing through the landscape. Glaciers carve through the hardest rocks because of their tremendous weight, their movement and their unrelenting renewal by snow and ice above. As the glaciers carved their way down to the lowlands, they ground the rock beneath them to a mixture of cobbles, sand and dust called "till."

These rivers of ice pushed glacial till into huge piles at the sides and end of their paths, just as a snowplow piles up snow. The thousand-foot-high mounds of gravel left behind are called "moraines." Moraines along the side of the valley are called lateral moraines. Where the glacier stopped advancing, it left a terminal moraine. The moraines mark the lower boundaries of a glacier.

Moraines can be one thousand feet higher than the valley floor. Many smaller "mountains" in the high country are really moraines.

Sometimes the moraines dammed up the meltwater coming down the valley and formed a lake. Grand Lake, the largest and deepest natural lake in the state, was made by moraines. Some smaller glacial lakes were filled in with sediments and now form meadows such as at Horseshoe Park in Rocky Mountain National Park.

Water Deposits

In between glacial periods in the Ice Age, the ice melted, and torrents of water plunged down the mountainsides. Energized by the heights from which it flowed, the floods of meltwater carried smaller stones and particles to fill in river valleys. The glacial rivers may meander (wander) across the broad valley floor, enough to create horseshoes or oxbows (bends in the river so tight that they resemble old-time ox bows, or yokes). When the river wanders in such big loops that it cuts itself off, it creates curved lakes called horseshoe or oxbow lakes. You can see examples of meandering rivers in Horseshoe Park and the Kawuneeche Valley.

Not all of the gravel stopped in the high mountain valleys. When glaciers bulldozed down the stream valleys, literal mountains of glacial gravel were washed down below the terminal moraines to clog the river valleys below. So much till filled V-shaped stream canyons that they sometimes look like U-shaped glacial valleys. Estes Park is broad and flat, not because it is a glacial valley but because it is a stream-cut valley filled with glacial debris.

Ten Thousand Years Ago to Today

All the glaciers from the last glacial event disappeared from Colorado ten thousand years ago; our current glaciers and snow fields are leftover from a cold spell called the "Little Ice Age," which started in about 1200 and ended around 1880.

Chapter 8
CLIMATE AND WEATHER

BREATHLESS

Colorado has the highest overall elevation of any state in the lower forty-eight, about 6,800 feet (2,073 meters), which is higher than the highest point east of the Mississippi (Mount Washington in New Hampshire at 6,288 feet or 1,917 meters). And *then* you climb into the mountains. While we are enjoying Colorado's spectacular mountain scenery, we are breathing less air than those at sea level. This can leave us breathless in more ways than one.

Thin Air

Everyone in the world lives at the bottom of a fifty-mile-thick layer of atmosphere. When you have fifty miles of air sitting on your head, it begins to get heavy. At sea level, the layer of air weighs about fifteen pounds per square inch. This is called barometric or air pressure—a measure of the force of the air pushing down on you.

Like a down comforter that needs to be shaken out, most of the air wrapped around the planet has settled at the bottom of the layer, near sea level. By the time we have made our way up a mile into the atmospheric comforter, there is 15 percent less air pushing down on us than at sea level. Denver, at 5,280 feet (1,609 meters), has an air pressure of about twelve

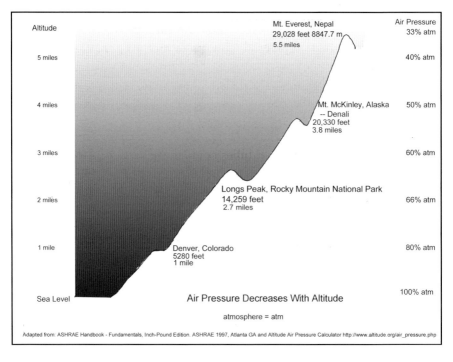

As you go up in altitude, the number of molecules in the air (represented by shades of gray) becomes less. We call this "thin air." *Courtesy the author.*

pounds per square inch. But on Trail Ridge Road, above 10,000 feet, one-third of Earth's atmosphere is below us. At this altitude, only about ten pounds sits on top of us. We usually call lower air pressure "thin" air.

Ear-Popping

The higher you go into the mountains, the thinner the air gets. As you change altitude, the atmospheric pressure outside your ear changes compared to the air trapped in your Eustachian tubes. An imbalance in pressure develops between the inside of your ear and the outside world, which is why your ears pop. Your Eustachian tubes allow the atmospheric pressure in your ears to stay at the same level as the atmospheric pressure outside your ears, so that your ear drums work properly. The Eustachian tubes do this by connecting the ear to the back of your throat, which is always at atmospheric pressure.

The system usually works pretty well, but it evolved to work with slow changes in pressure, like weather fronts blowing through or your hiking up

a mountain trail. The quick changes in air pressure created by driving up a steep canyon road or an airplane climbing at takeoff ask a bit much of these little pressure-relief tubes. Occasionally the Eustachian tubes get plugged and don't do their job perfectly. When they don't, you get the familiar pressure on the ear drum.

If the Eustachian tubes don't open by themselves, yawn, chew some gum, sing with the radio, yell at the kids—anything to work your jaws back and forth. Since the Eustachian tubes connect your ear with your throat, shifting your jaw widens the tubes momentarily and allows the pressure to equalize with a pop.

Lower air pressure means three-minute eggs take four minutes to cook in Denver because water boils more quickly and at a lower temperature, 203°F (95°C) instead of 212°F (100°C) as at sea level. Thinner, less dense air means more home runs and longer field goals, bluer skies and brighter stars.

Ultraviolet Light

Less dense air also means less ozone at high altitudes to filter out ultraviolet (UV) light. Coloradoans are at higher risk for wrinkles, skin cancer and blindness than our lower-altitude friends. Be sure to use your sunscreen and wear your sunglasses.

Oxygen

One-third less total air also means one-third less total oxygen. To compensate for less oxygen, our bodies increase the number of red blood cells in our circulatory systems. It takes from three days to two weeks for our bodies to adapt to the higher altitudes so that we feel normal again.

Olympic-caliber athletes, always looking for an edge, often train in Colorado to take advantage of their bodies' response to high altitude. By training at high altitude for a few weeks just before competition, their bodies add red blood cells to compensate for less oxygen. When they return to a lower altitude to compete, they are naturally turbo-charged with more red blood cells that take more oxygen to their exhausted muscles.

Altitude Sickness

Sometimes the extra red blood cells are not enough to compensate for our oxygen-deprived altitude. Visitors to the high country can develop headaches, dizziness, nausea or sleep problems when they first come to the mountains. They probably have altitude or mountain sickness. Even people acclimated to Denver's altitude can get altitude sickness during a trip to the high mountains.

Early symptoms of altitude sickness can sometimes progress to include fluid buildup in the lungs, lack of coordination, confusion, loss of memory, coma and death. These usually happen after a long stay above 10,000 feet. Altitude sickness can be serious, even life threatening, but it usually is easily treated. Avoiding altitude sickness is the same as treating it; you just start sooner:

- Take it easy and limit your activities, especially the first few days. Drink plenty of water and avoid alcohol, nicotine and other depressants like sleeping pills. Give yourself plenty of time to adapt to our rarified air.
- "Climb high, sleep low" is the motto that hotshot climbers live by. Enjoy your outing at a higher altitude and then return to a lower altitude to sleep. Go down, too, if anyone in your group shows signs of altitude sickness. Go back up when everybody can enjoy the outing.
- If these simple preventative measures are not possible, or if somebody in your group still shows symptoms, see a doctor immediately. There are medications to prevent or treat altitude sickness.

Thunder and Lightning

Thunderstorms are common in the mountains in spring and summer due to the air disturbances created by the mountains. Thunder and lightning are, of course, the defining parts of a thunderstorm. If you ever feel your hair standing on end, lightning is about to strike, and very near *you* is where it is planning on hitting. You are in very great danger—*get down*!

When it hits, lightning explodes in sun-scorching heat, eye-searing light and heart-stopping electrical energy, accompanied by an ear-numbing crash. Do not be nearby when this happens. Lightning causes more deaths than

tornadoes or hurricanes. Colorado is second in the country for lightning deaths; a high number of these happen in the mountains.

The best place to take shelter in a lightning storm is under the cover of a building. Your car is a very safe place to be, as long as it has a hard roof. If you are in the high country, get among big rocks or below timberline, under a canopy of many trees. Never stand under a lone tree, as it is the tallest thing around.

30/30 Rule

As children, most of us learned the trick about counting slowly between seeing a flash of lightning and hearing the thunder to figure out how far away a lightning bolt has struck. Remember that there are five seconds to each mile between flash and sound. Counting to five means the lightning is one mile away, not five. To be safe from lightning strikes, you need to be six miles away from the lightning, or to be able to count to thirty. A "bolt from the blue" can kill you even if there isn't a cloud nearby, so don't go outside again for thirty minutes after the last lightning flash. This is called the 30/30 rule.

Westerly Winds

The constantly blowing winds in Colorado are called westerlies; they are the norm from which all other winds deviate. Westerlies are generated by the rotation of the planet. At 10,000 feet, westerlies blow at a fairly steady fifty miles per hour in winter, and it's not uncommon for them to howl at one hundred miles per hour. The jet stream actually dips down to skim the top of Longs Peak at times, hammering it with gusts of over two hundred miles per hour! Few places in the world have higher wind speeds than the alpine.

Westerlies are the winds that bring rain and snow to the state. Because they come from the west, they hit the west side of the mountains first. And that, in turn, means that the Western Slope of the mountains gets more water than the Front Range. Grand Lake receives nineteen inches of moisture, while Estes Park, in a rain shadow, gets just fourteen inches of moisture a year.

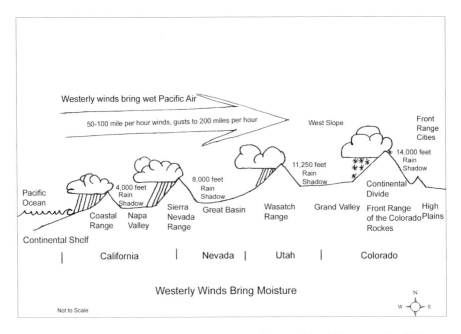

Wet air blowing in from the Pacific is wrung out on the west side of the mountains. This creates a dry "rain shadow" on the east side. *Courtesy the author.*

WATER

Where the water falls matters. The three most dramatic man-made features in Rocky Mountain National Park all have to do with water diversion to the Front Range. The Lawn Lake Alluvial Fan was created when the Lawn Lake dam, built to hold irrigation water, burst. The Grand Ditch was dug to take water from the Western Slope across a pass to Long Draw Reservoir and, from there, to farms on the plains. And just outside the park, Lake Granby and Shadow Mountain Reservoir are both designed to hold west slope water until it can be piped east, through a tunnel under the park.

Why go to so much trouble to move water over the Continental Divide? Because although about 80 percent of all the water that falls in Colorado falls on the Western Slope, 80 percent of the state's population is along the Front Range metro area.

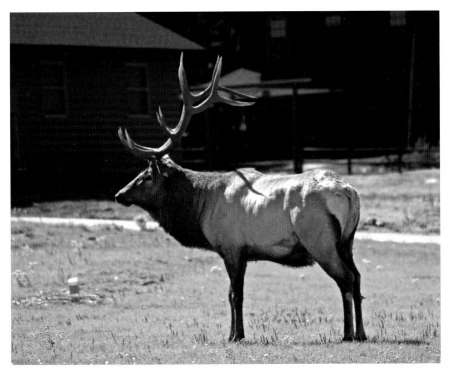

Elk are big, tan animals with a shawl of dark fur around their necks. They often come into Estes Park. *Courtesy the author.*

Mule deer are animals of the twilight. They rarely venture far from forest cover. *Courtesy Dick Vogel.*

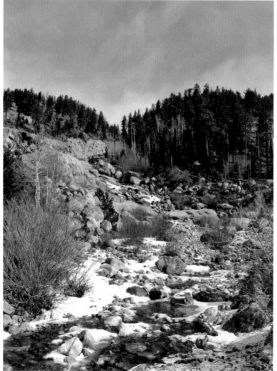

Above: Black-and-white Magpies eat dog food, carrion and insects like the parasites of this spike-antlered elk. *Courtesy Duncan Ziegler.*

Left: Lawn Lake Alluvial Fan. In August 1982, floodwaters roared into Horseshoe Park and dropped these rocks. *Courtesy the author.*

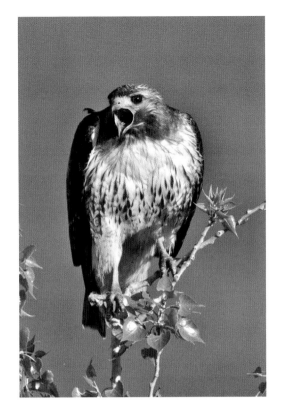

Right: In addition to having red tails, Red-tailed Hawks have dark heads and white chests with a striped "belly" band. *Courtesy Dick Vogel.*

Below: Bull elk spar every fall to see who gets to have a harem of cow elk. *Courtesy Alaine Ziegler.*

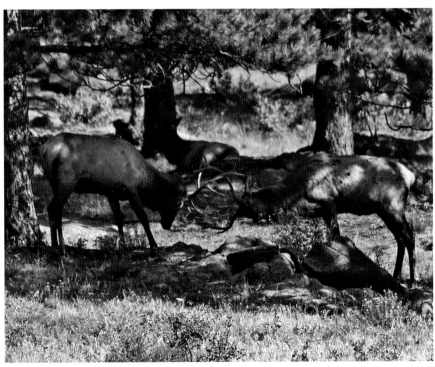

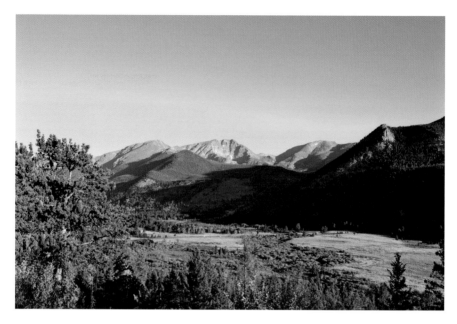

Mount Ypsilon above Horseshoe Park. Bands of metamorphic rock form the horizontal crevasse on Mount Ypsilon. Elk often graze in the park below. *Courtesy the author.*

Medium-sized Clark's Nutcrackers use their large beaks to open pine cones to get at their nuts. *Courtesy the author.*

Smallish Gray Jays use their sharp beaks to eat berries, insects and small animals. *Courtesy the author.*

Steller's Jays mostly eat seeds, berries, insects and other small animals. They live from the foothills to the spruce-fir forest. *Courtesy the author.*

Beaver, the largest rodents in North America, eat grasses and forbs in the summer; in winter, they eat bark from branches they've submerged. *Courtesy Dick Vogel.*

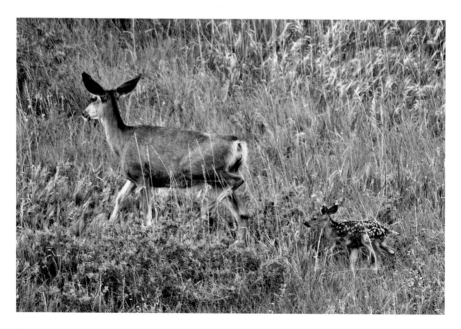

The spots on this mule deer fawn help hide it from predators. *Courtesy Dick Vogel.*

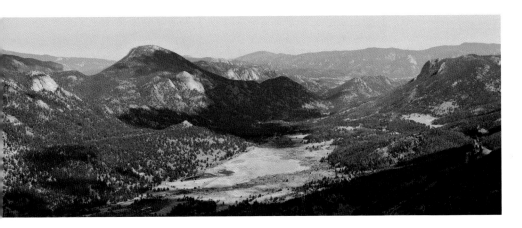

Lateral moraines can easily be seen on either side of Horseshoe Park. *Courtesy the author.*

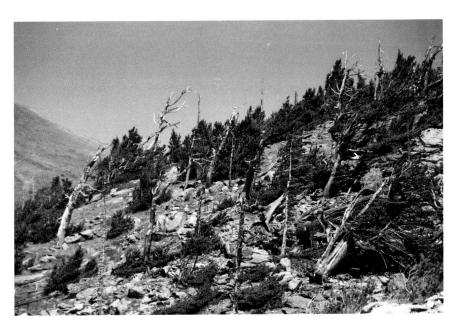

This stunted krummholz forest was made by winter winds howling up the slope. The upper edge of the krummholz is timberline; no trees survive above it. *Courtesy Robert Law.*

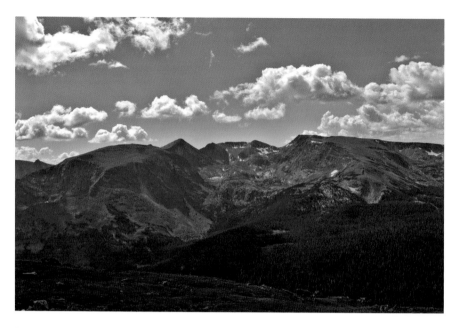

Surrounded by Terra Tomah, Mount Julian and Mount Ida, the Gorge Lakes stair-step down the hanging valley to the Forest Canyon rim. *Courtesy the author.*

The large flowers of arctic gentians attract a surprising number of insects to pollinate their seeds. *Courtesy the author.*

Above: The red tips on the buds of alpine avens betray pigments that convert sunlight to heat and act as antifreeze and sunscreen. *Courtesy the author.*

Right: Marmots are also called "rock chucks" for their habit of denning in the talus and "whistle pigs" for their chirping alarm call. *Courtesy Dick Vogel.*

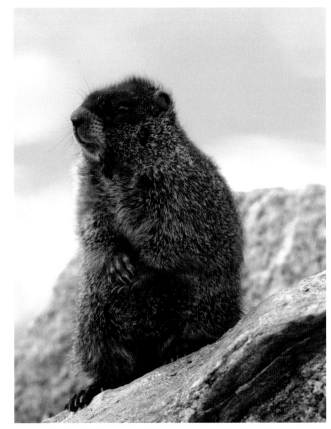

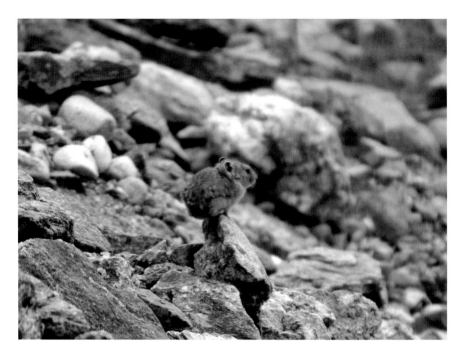

Above: Pikas are most closely related to rabbits. They emerge from their rocky dens under the snow to find food under the drifts. *Courtesy the author.*

Below: Trail Ridge Road opens in late May or early June—as soon as plows can cut through the deep drifts. *Courtesy Robert Law.*

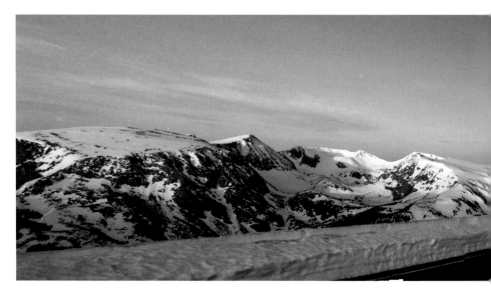

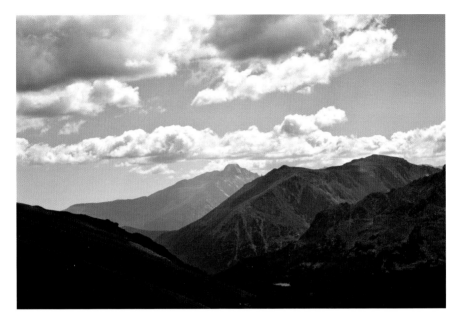

Above: At 14,259 feet (4,346 meters), granite Longs Peak is the only Fourteener in Rocky Mountain National Park. *Courtesy the author.*

Right: The golden sheen of feathers across the necks of Golden Eagles gave the great birds their name. *Courtesy Dick Vogel.*

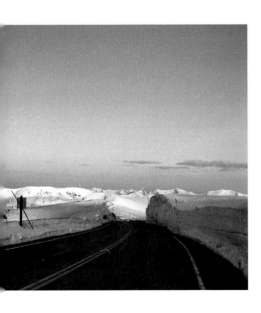

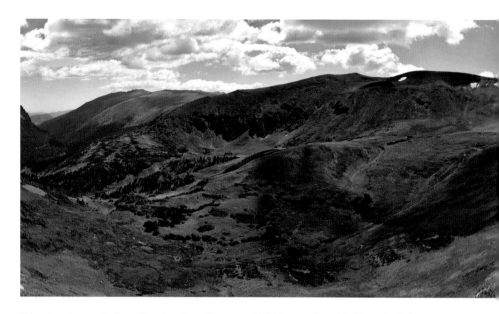

Fall River Cirque is three-fourths of a mile across (1.2 kilometer) and half a mile (0.8 kilometer) deep. *Courtesy the author.*

Poudre Lake on the Continental Divide at Milner Pass. The sliver of mountain above the forest on the right is Trail Ridge Road. *Courtesy the author.*

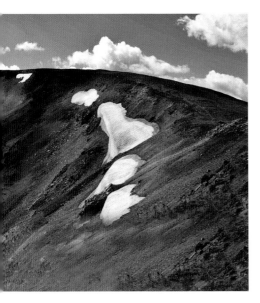

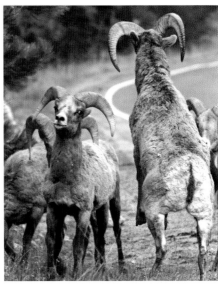

Above, right: Bighorn sheep rams vie for dominance. *Courtesy the author.*

Below: The Green Knoll, Mount Stratus and Mount Nimbus in the Never Summer Range. The Grand Ditch cuts across the base of Red Mountain. *Courtesy the author.*

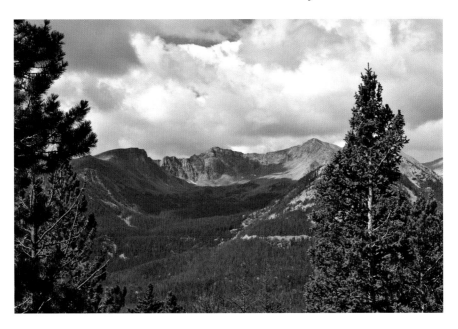

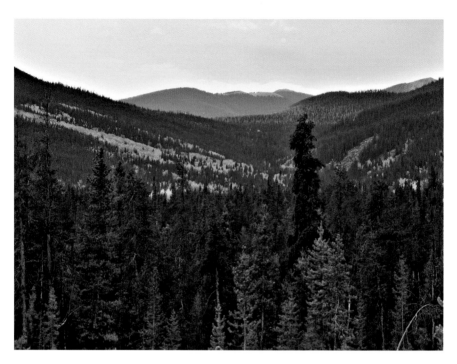

Above: Golden quaking aspen and dying lodgepole pine. With time, the beetle-killed lodgepoles will be replaced by the aspen. *Courtesy the author.*

Left: Compare the number of plants growing beneath the aspen to the understory of a lodgepole forest. *Courtesy the author.*

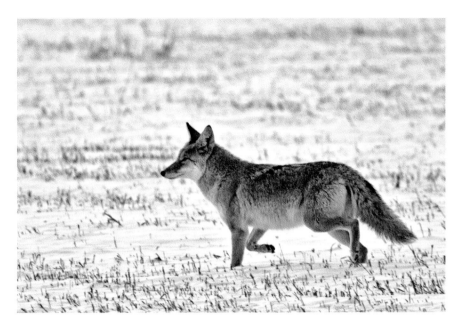

Coyotes are smaller than wolves but bigger than foxes. These in-between carnivores are currently the main predator of Rocky Mountain National Park. *Courtesy Dick Vogel.*

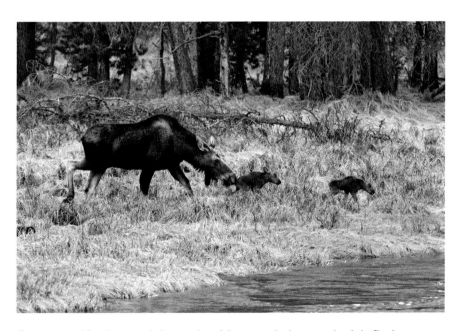

Cow moose with calves travel along a river. Moose are the largest animals in Rocky Mountain National Park. *Courtesy Dick Vogel.*

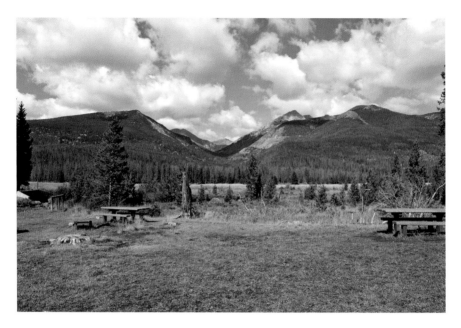

Bowen-Baker Gulch. The *U* shape of a glacial valley is easy to see here. *Courtesy the author.*

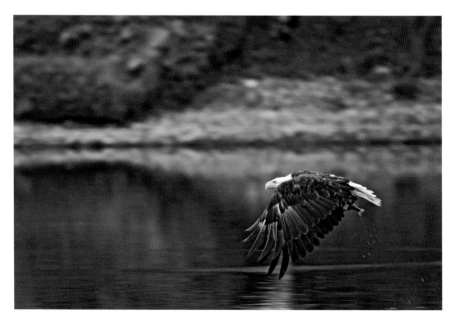

As a fishing eagle, Bald Eagles are found near water such as Lake Estes, Grand Lake and Shadow Mountain Reservoir. *Courtesy Dick Vogel.*

Snow and Snowpack

The mountains create a unique water source called "snowpack." The name tells you what it is—the amount of snow packed or built up in the mountains. Throughout the West, blizzards can howl on the plains, but they rarely produce enough moisture for the people who live there to use throughout the year. On the other hand, the more snow that builds up in the mountains, the more snow melts to fill the reservoirs. If there is a poor snowpack in the mountains, water use will be restricted in many communities lower down. The "water year" begins in October because this is when the snowpack begins to build.

In the spring, factors that affect snowpack melt are temperature, humidity and wind. If the temperature rises too quickly, the snowpack will melt too fast, causing flooding. Low humidity, often caused by warm "chinook" winds, can eat up a season's snowpack in a few days, putting downstream users in water-use restrictions equally fast.

Chapter 9
TREES AND SHRUBS

The difference between trees and shrubs is that trees are tall and have one to several trunks, while shrubs are shorter and have many stems.

DECIDUOUS TREES AND SHRUBS

The word *deciduous* means that something falls off. When used to describe trees, it means that they lose their leaves in the fall. These trees are sometimes called "broadleaf" trees. Generally speaking, deciduous trees don't take dry spells very well. This means that they tend to grow where they are watered by snow, rain or groundwater on a regular basis.

Willows

There are several types of willows in Rocky Mountain National Park. Water-loving willows either live near lakes or streams or send roots deep into the soil to find the water table. One way or another, willows keep their roots wet. In spring, they produce dangling catkins, which hold their tiny flowers.

Willows grow fast and die young, often living less than one hundred years. One fun fact is that the leaves and bark of the willow family contain salicylic acid, an early form of aspirin.

Willow Shrubs

There are many different types of willow shrubs in the Rocky Mountains. All look basically the same: long, toothed leaves on long, slender, yellow, red or orange stems. The shrubs themselves have many stems, from nine feet tall along streams to just inches above the ground in the tundra. In the mountains, willow shrubs grow along streams or in wet meadows from the foothills to the tundra.

Willow shrubs are a favorite food of many animals. Ptarmigan, the only bird to stay in the alpine tundra through the winter, survives in part by nibbling on the highly nutritious willow buds. Elk have browsed willows so heavily in several of the parks that the National Park Service has been forced to fence off parts of the meadows to let the shrubs recover. They are major food sources for beaver and moose as well.

Quaking Aspen

Quaking aspen is a native tree in the willow family. It grows 25 to 150 feet (7.6 to 45.7 meters) high and has a rounded crown. The saw-toothed, round-but-pointed light-green leaves turn bright yellow to reddish after the first frosts, making aspen the pride of Colorado. The leaves are attached to the branch by a slender stem that allows them to shake in even a light breeze. The trembling leaves give the tree both its common name (quaking aspen) and the scientific name (*Populus tremuloides*). People sometimes call them "quakies" for the same trait.

Aspen bark is smooth and white. When scratched, the bark turns black. The black scratches often record the passing of male deer and elk rubbing the velvet off their antlers, as well as bears stretching up with their claws to mark their territory.

Quakies reproduce mainly by suckers—sending up stems from roots up to 90 feet (27.4 meters) from the parent tree—letting the aspen spread quickly and making them almost impossible to kill once they are established. This can be a remarkably successful strategy—an aspen tree near the Wasatch Mountains in Utah may be the world's most massive known organism. It occupies 17.2 acres and has more than forty-seven thousand stems—scientists estimate that the original tree sprouted 1 million years ago. Stands of quaking aspen may consist of a single tree or represent several different trees growing together.

This strategy of sending up suckers works the world over. Quaking aspen grow from the northern shores of Canada to scattered locations in central Mexico, making it one of the most widespread plants in North America. Another very closely related species grows from England to Japan and south to Spain, Turkey and North Korea.

Animals from mule deer to porcupines to black bear eat aspen bark, buds and twigs. Because light gets to the floor of an aspen forest, other plants can grow under the trees, providing habitat and food for all sorts of critters.

The network of roots produced by aspen clones holds the soil of disturbed areas, keeping it from running off into streams. And aspen leaves decay quickly, adding nutrients to the soil. Without leaf litter on the ground to carry a fire, aspen stands create good fire breaks. With their thin bark, fires easily kill the above-ground portion of the aspen tree. But as long as the fire wasn't too hot, all the tree has to do is sprout from suckers to begin again.

Ancestral Puebloans (Anasazis) used aspen bark to make boxes. Today, aspen wood is used for pulp products like fiberboard. Because it doesn't have a taste, popsicle sticks and tongue depressors are also made from aspen wood.

Coniferous Trees

Coniferous trees (conifers) like pine, fir and spruce have scales or needles instead of leaves. These trees are often called "evergreens" because their needles don't turn yellow, red or brown and drop off in the fall. Needles don't lose as much water as broadleaf leaves, and needle-bearing trees tolerate cold better, so conifers do well in the Rocky Mountains.

Pine Trees

Pine trees have needles that grow in clumps of two to five along the ends of branches. Pines prefer drier sites than other trees—you can often find them growing in full sun on sandy or gravelly soil. They have classic woody "pine" cones. All the other trees' "pine" cones are actually papery spruce or fir cones or juniper berries.

Pines use one of two strategies when it comes to spreading seeds. The first strategy results in seeds growing new pine trees near the parent trees. These

pines produce cones with a spine or bristle at the end of each pine cone's scales to keep animals from pilfering the seeds. Their seeds often have paper "wings" to help them float at least a little distance from the parent tree. Ponderosa and lodgepole pine use this strategy.

The other strategy is to scatter the pine seeds far from the parent. To do this, the trees enlist animals to distribute the heavy pine seeds. To make it easy for the animals to get to the seeds, the cone scales have no spine. These pine trees also produce huge amounts of seeds every few years so that the animals' populations have plenty in good years to cache, or bury, for later use; on the other hand, the animal populations don't grow so much that they eat all the seeds at once. Many of these caches are forgotten and so are free to sprout new trees in new territory. Limber pines are famous for the number of seeds that they produce.

Ponderosa Pine

When ponderosa pines are mature, they are medium-tall cylindrical trees with rounded tops. Ponderosa branches are open and point straight out from the trunk, rising at the tips. The long needles grow in bundles of three (sometimes two or five).

The large, woody ponderosa pine cones have big scales, each of which has a small bristle on the end to discourage animals from eating the seeds. The cones often remind people of a pineapple, although the two plants are about as distantly related as it is possible to get and still photosynthesize.

Big woody pineapple-shaped ponderosa pine cones have a spine on each scale. Note how long the needles are. *Courtesy the author.*

As it ages, a ponderosa develops thick reddish, vanilla- or butterscotch-scented, fire-resistant bark. This bark protects the tree from the frequent ground fires that thin out shrubs and younger and sick trees. These fires create open stands of trees called savannas.

Between 90 and 250 years of age, ponderosas approach maturity. We all tend to round out a little as we age; for ponderosas, it's their

crowns that become rounded. The trunks of mature trees may approach three to four feet in diameter. The name *ponderosa* comes from "ponderous"; evidently somebody thought the trees looked heavy.

The open spacing of ponderosa savannas keeps cool ground fires from getting hot enough to get into the crowns of the trees, destroying them. The spacing also keeps bark beetles from jumping from tree to tree easily. The word *savanna* (or *savannah*) comes from the Arawak Indian word for "grassland without trees." It has come to mean a grassland with scattered trees. The city of Savannah, Georgia, takes its name from the Savannah River, which, in turn takes its name from a group of Shawnees who settled along it. Whether or not these people had anything to do with grasslands is unknown.

Because the ponderosa savannas are more open, more grasses grow among these trees. Ranchers took advantage of this grass during the cattle boom from the late 1800s to World War I, and in many places, the open ponderosa forests were overgrazed. People from the Ancestral Puebloans (Anasazis) of the southwestern United States down to today have used ponderosa for building. Utes of western Colorado used the ponderosa as a food source, the sap for its sweet taste in good times and the inner bark as a starvation food in bad times. You can still see some scarred pine trees at old Ute camps. They also used the wood for tools.

Ponderosa pine is one of the most important timber species in the western United States, and it is *the* most important timber tree in Colorado. Strong and knot-free, ponderosa pine makes excellent lumber for cabinet and construction work. It is used for veneer, core stock and sheathing. In addition to traditional grazing and timber harvesting, today ponderosa forests are heavily used for recreation and, outside national parks, for hunting and mountain homes.

LODGEPOLE PINE

Lodgepole pines got their name because the tall, straight trees are perfect for the poles needed to hold up tepees, or lodges. Plains tribes traveled many days to get to a stand of lodgepoles, often to middle to high elevations of the mountains. Southern Colorado is the southern limit of the tree's range.

The lodgepole's branches droop as they leave the trunk and then rise at the ends like an Oriental pagoda. Toward the ends of the branches, pairs of medium-length, slightly twisted, dark-green needles give a powder-puff look. Lodgepoles grow in crowded stands, and their branches are very short and spindly. The lower branches die off, making the tree look like a very tall stick.

This woody lodgepole pine cone needs a very hot day or a fire to open it and release its seeds. Note the lodgepole's short needles. *Courtesy the author.*

Small lopsided lodgepole pine cones develop every year, but only some drop to the forest floor. Many remain on the tree for several years. Each woody cone scale has a sharp spine on its tip, and pitch or resin (stickier than sap) glues the cones shut, sometimes for years. The cones are waiting for a fire or a very hot day to open them up and release the seeds. If a fire has opened the cones, it has also cleared the forest of trees, opening the way for lodgepole seedlings. Lodgepoles grow on gravelly or sandy soil in harsh, dry sunlight and so are some of the first trees to come in after a fire. This is why lodgepoles often grow in dense even-age forests called "doghair stands."

The doghair stands of lodgepole create a dark forest, beneath which little grows. Between the sharp spines on their cones and the pitch gluing the cones shut, not even seed-eaters find much to eat in a lodgepole forest.

Mountain pine beetles are one of the few creatures that do find something to eat in a lodgepole pine forest, and they feed on the trees themselves. These native beetles eat the soft inner bark of the tree, where nutrients and water move up the trunk and starches and sugars move down. When the mountain pine beetles fly to new trees, the densely packed doghair stands of lodgepoles make them easy targets.

From 1996 to 2013, millions of acres of lodgepoles from Colorado north into Canada were killed by mountain pine beetles. In many areas of the northern Rockies, whole mountainsides are covered with dead, rust-colored lodgepoles. It is sad to see the wholesale destruction of entire forests. But as aspen and shrubs sprout in the openings left by lodgepoles, and as animals move in to eat the plants, we will have more diverse forests.

The standing dead lodgepoles are an obvious fire danger. Equally obviously, if they were going to die anyway, it would have been nice to cut the lodgepoles outside the national parks for timber.

There are several problems with harvesting the beetle-killed trees. First, there has never been much of a market for lodgepole pine. Second, much of the timber is on steep slopes that would be expensive to cut. These first two problems are why the forests were not cut in the first place. Third, even if we could have instantly and economically built enough sawmills to handle millions of acres of dead trees, the salvage operation would have lasted five years at most. After that, the standing dead timber would have been too rotten to be used for anything except firewood. Fourth, once the salvage operation was done, what do you do with all the sawmills?

In spite of the fact that the animal density and diversity are low, these forests provide important services in holding soils of disturbed areas and slowing runoff, thereby minimizing sedimentation of streams.

Spruce Trees

Spruce trees grow on moist sites in a classic "Christmas tree" cone, tapering from a wide base with branches that sweep the ground up to a pointed crown. Their papery cones dangle from upper twigs like ornaments. Unlike pine or fir needles, you can roll the square spruce needles between your fingers. But be careful when plucking them—the sharp, sometimes stiff spruce needles line the entire branch. "Spikey spruce" will poke you if you grab it.

Blue Spruce
Stately and dramatic, blue spruce can grow to 150 feet (45.7 meters), tapering to a point from a wide base. Their upper branches point up, and their lowest branches are widest and often touch the ground. Single, square, very stiff blueish-green to blueish-silver needles cover the branches. Their papery cones hang down from the top branches, dropping to the ground when mature.

Papery Englemann spruce cones like this look very similar to blue spruce cones. Both are favorites of seed-eating animals. *Courtesy the author.*

Unusual for evergreen conifers, blue spruce prefer moist soils and often grow along rivers in Douglas-fir or Englemann spruce–subalpine fir forests. As long as their roots are moist, blue spruce grow from foothills to timberline.

As beautiful as the living tree is, blue spruce wood is brittle and full of knots, so it isn't used for lumber much. Instead, the trees are sometimes cut for Christmas trees, including the National Christmas Tree that stands outside the White House.

Blue spruce is the state tree for Colorado and Utah, but they are planted as ornamentals across the northern states.

ENGLEMANN SPRUCE

Englemann spruce trees normally grow into narrow cones up to 180 feet (55 meters) tall, but on windy sites, the trees may be reduced to ground-hugging shrubs. Their drooping branches are covered with single, square, blueish-green needles, as well as papery cones hanging down. Englemann spruce reach maturity at 350 years and can live to be 800 years in age.

Englemann spruce grow in dense stands on moist soils covered with litter or "duff" (needles and other plant material). They grow at high altitudes—from 9,000 feet (2,743 meters) to timberline—because they can withstand deep

snowpacks and frigid temperatures. What Englemanns can't tolerate is direct sun—seedlings can only survive in moist soils under the shade of another tree. This is fine in an old-growth spruce-fir forest, where the shade is dark and the duff is deep. But if an Englemann spruce forest is burned or clear-cut, it has to wait for generations of lodgepole pines or quaking aspen to create enough shade and build up enough litter to allow the spruce seedlings to grow again. We are talking hundreds of years depending on the altitude of the site.

Spruce can reproduce by layering—sprouting stems from branches or roots that reach far from the trunk of the tree. This adaptation allows them to reproduce in the short growing season of higher altitudes.

Englemann spruce often grow with subalpine fir in forests that hold more snowpack and so yield more water than any other mountain plant community. Preserving the forest as a water-storage facility is usually a more valuable use than harvesting its knotty wood.

Fir Trees

Tall and narrow, fir trees are the spires of nature's cathedral. The branches of mature trees stick straight out or droop, emphasizing their height. Fir trees' single needles line the entire branch. The needles are flat—they won't roll in your fingers. The needles are also soft so that when you grab them, they don't poke—they are "friendly firs."

Subalpine Fir
Subalpine fir trees grow in a tall spire. Their flat, soft needles are deep blue-green and line the branches in single file. Subalpine fir's papery cones are usually at the top of the tree. The cones point up and break apart at the end of the season, characteristics that make them true firs.

Cool summers, cold winters and deep winter snowpacks are more important than total precipitation in determining where subalpine fir trees grow. These fir live in deep shade from middle altitudes right up to timberline.

The growing season at high altitudes is very short—it can frost any day of the year. The season can be so short that trees can't set seed. Subalpine fir dodge this problem by layering.

Subalpine fir grow in large forests alongside Englemann spruce. The wood of both of these trees is too brittle, knotty or rot-prone for lumber. That means that the deep, dark spruce-fir forests look much as they did hundreds of years ago.

Growing high in the mountains, the spruce-fir forest catches more water than any other plant community. The deep shade created by the spruce-fir forest holds the snowpack, often until it is summer at lower elevations. Without the shade of the spruce-fir forest cover, water quality and quantity would suffer greatly.

DOUGLAS-FIR

Douglas-fir trees grow tall in a cone, with branches down to the ground—a classic Christmas tree shape. The light-green needles that cover the branches on these trees are soft and flat, prompting the forestry student's memory trick "friendly fir." Thick, "corky" bark protects mature Douglas-fir trees from forest-thinning ground fires, but they sometimes grow in dense stands, which make them easy victims of *Ips* beetles and hot, dangerous crown fires. Shallow root systems mean that Douglas-fir can easily blow down.

The papery cones of Douglas-fir trees have a distinctive three-pointed bract that looks like a mouse's haunches and tail disappearing into the cone. The cones hang down from the branches and don't fall apart when they mature. These two facts sets them apart from true fir trees, which is why "Douglas-fir" is hyphenated.

Papery Douglas-fir cones don't break up when ripe as subalpine fir cones do. Can you find the "mouse" hind end disappearing into the cone? *Courtesy the author.*

Douglas-fir prefer cool, shady, moist areas at low to middle altitudes. As they mature, Douglas-fir trees in Colorado can reach one hundred feet in height; in the Pacific Northwest, with warmer temperatures and lots of water, they can become truly huge—three hundred feet tall, thirteen feet across and one thousand years old.

The Pueblo peoples used Douglas-fir logs to build pueblos, while the twigs were worn on various parts of dancers' costumes. Prayer sticks made of Douglas-fir wood dating back to the Ancestral Puebloans have been found at archaeological sites in New Mexico.

One of the most important timber trees in the world, Douglas-fir's light, strong wood is perfect for building lumber. Timber cutting for lumber in the late 1800s cut many of the best stands of Douglas-fir in Colorado, especially in the "Mineral Belt," which ran diagonally from the San Juan Mountains to Boulder. Today, the remaining trees grow on steep slopes with other noncommercial trees scattered among them, and they aren't as huge as their brethren in the Northwest. Therefore, Douglas-fir aren't as commercially important in Colorado, being cut mostly for Christmas trees.

Chapter 10

MAMMALS

HERBIVORES

Herbivores eat plants. This can be anything from flower nectar that is on a hummingbird's menu to bark that beaver and moose consume. Most herbivores are someplace in between, eating grasses, shrubs or non-woody flowers, leaves and stems.

Ruminants

All of the big plant eaters in Rocky Mountain National Park are ruminants (grazers that chew their cud—mule deer, elk, moose and bighorn sheep). All ruminants need lots of salt to digest their food and so seek out natural or man-made salt licks, such as at Sheep Lakes.

ANTLERS VERSUS HORNS
Among deer, elk and moose, the males (buck deer and bull moose and elk) have bony antlers, not horns like cattle, sheep or goats. Antlers typically start as thin spikes when the males are two years old and get bigger and heavier, with more points, as they age; mature males can carry large racks. They shed their antlers every year around March. In April, the antlers begin to grow again. By August, the "velvet," or fuzzy skin that nourished these huge

pieces of bone, has done its job. As it dies off, the velvet itches. The bulls rub their antlers against anything they can find—aspen trees, shrubs, even buildings—to get rid of the velvet.

Both sexes of cattle, sheep and goats grow horns, the female's horns being smaller and lighter than the male's. Horns are made of keratin, the same stuff that composes hair and fingernails. To make horns, keratin grows as a covering around a bony stem. That means that horns don't drop off; they continue to grow thicker and heavier as the animals age.

MOOSE

Moose are the biggest animals in Rocky Mountain National Park today. Bulls can be 9.5 feet (3 meters) long, 6 feet (1.8 meters) tall at the shoulder and weigh more than 1,000 pounds (454 kilograms).

Need more to identify them? Long legs let moose wade in lakes and streams and "posthole" step through deep snows with an up and down motion as opposed to having to wade through them. A bulbous nose supports thick lips that hold twigs in place so that the moose can bite through the wood. In fact, *moz* is the Algonkian word for "twig eater." Both sexes of moose have a "bell" or "dewlap" dangling from their throats.

A moose's most iconic characteristic is its flattened antlers, sometimes called "paddles," which only grow on bulls. Antlers of bulls in their prime may weigh over 50 pounds (23 kilograms).

Moose were introduced into Colorado's North Park, just west of the Never Summer Range, in 1978 and 1979. Since then, they have spread out across northern Colorado. Today in Rocky Mountain National Park, they can often be seen at the head of the Kawuneeche Valley.

Moose habitat is usually mixed forests and riparian (streamside) areas with lots of willow and aspen. They retreat to coniferous forests for resting and safety. Moose may move into the subalpine or tundra in summer.

The diet of a moose is 80 percent wood, mostly twigs, buds and bark. They prefer broadleafed trees, especially willow and aspen, as well as serviceberry and other shrubs. In summer, moose enjoy aquatic plants.

Moose can be very temperamental and dangerous. They are excellent swimmers, and on land they can run very fast. Don't be close enough to them for this to be a problem.

When you're as big and bad tempered as an adult moose, not many other animals bother you. But up to 80 percent of young calves are killed by black bears and wolves. Deep, long-lasting snows may keep moose from finding enough twigs to hold off starvation.

In Europe, moose are called "elk." The confusion got started because European moose don't have the flat tines on their antlers that North American moose do. When Europeans first saw wapiti, they assumed anything that big had to be an elk. Now you know.

Elk or Wapiti

The name *wapiti* is an Algonkian word, from either the Cree or Shawnee Indians. Scientists prefer *wapiti* to *elk* because "elk" means "moose" in Europe, but the name switch is having a hard time sticking.

Elk are some of the biggest free-ranging animals left in North America. Both sexes of wapiti are tan to buff, with a shawl of darker fur around their neck and shoulders. They stand 4 to 5 feet (1.4 to 1.5 m) tall at the shoulder. A small cow may only weigh 400 pounds (181 kilograms), but a mature bull elk can be as big as half a ton!

Wapiti are adaptable grazers and browsers, with grass and shrubs making up most of their diet. In fact, early explorers found huge numbers of elk on the plains and grasslands.

In the Rocky Mountains, elk prefer the "ecotone" or edge habitat—that area that forms the boundary between meadows, where they graze, and trees and shrubs, where they take cover and rest. Wapiti migrate vertically, going up to high tundra meadows to calve in the spring and coming down to the lower parks to mate in the fall. As snows bury grasses in winter, the animals switch to eating woody plants like willows and aspen.

Bull elk have bony antlers, starting with thin spikes when they are two years old and getting bigger, heavier and with more points as they age; mature males have huge racks. Wapiti fill parks and meadows in the fall during mating season, called rut. Mornings and evenings, you can hear their whistle-like "bugles" that announce their presence. (Elk bugles were used as the hunting cry of the Nazgûl as they searched for the hobbits in the *Lord of the Rings* movies.)

In September, the bulls begin to spar with one another to see which becomes a "harem master." Rivals lock antlers, trying to push each other back in contests of strength. The winner, usually the larger bull with the biggest antlers, gets to mate. The loser goes in search of a less daunting foe. The winning bull gathers as large a harem of females as he can defend against other bulls. Bulls would rather herd their harem than eat, and so they often go into winter in poor condition. If snow comes early, the dominant bulls may not have enough fat on them to survive the winter.

Around the end of May, the cows wander a little way away from the herd and give birth to their calves. The stick-legged baby can stand within hours

of birth and soon rejoins the herd. There is safety in numbers. The calves grow quickly and are weaned in the fall. The young stay with the harem for another year before the young bulls are pushed out. The young males form loose "bachelor" bands of their own in which they practice pushing one another around and dream of when they can challenge the big boys.

Unrestricted hunting and habitat loss to mining, ranching and farming pushed wapiti to extinction in many parts of the country. Conservation laws passed in the early part of the 1900s saved the remaining elk. Managed hunting now keeps the elk from eating themselves out of house and home.

Elk are the state animal of Utah.

Mule Deer

Mule deer are the only deer to live in the mountains of Colorado. Their large, mobile ears give them their name. They are large, tan to brown animals with a white rump and narrow black-tipped tail, which gives them their other name: black-tailed deer.

Only bucks have bony antlers, starting with thin spikes when they are two years old and getting bigger, heavier and with more points as they age; mature bucks can have large racks. Does (females) don't have antlers at all.

At 3 feet (.9 meter) high at the shoulder, deer weigh less than half as much as wapiti. While elk form herds, the basic deer unit is usually a doe with fawns. Sometimes two groups of deer travel together, but rarely more. The half-light of dawn or dusk is the most likely time for deer to be active, as they come out of cover to graze in meadows. They bed down in the dense cover of shrubs during the day, often facing the most likely direction from which danger will come.

As "browsers," deer prefer to eat the tips of shrubs and young trees. That means that they don't compete with "grazers" (grass eaters) like elk, cattle or sheep for feed. Mule deer eat the food sources that are the highest in protein in any season. In spring they eat new grasses and forbs (non-woody flowering plants). They switch to twig tips and woody vegetation as snows cover the ground.

You can find "mulies" from mountain shrub to alpine tundra. They prefer the ecotones (edges) of meadows and recently burned areas, where they can feed on new growth yet bed down in heavy brush. Mule deer migrate down to lower elevations in winter to avoid snow, often coming into towns. In Colorado, mule deer are a mountain lion's main prey. Deer also are food for coyotes and, in wilder areas of the country, wolves.

Unrestricted hunting had almost wiped out mule deer along the Front Range by 1900. Now, hunting regulations have allowed mule deer populations to rebound to the upper limit of what the remaining habitat can support.

BIGHORN SHEEP

Bighorn sheep are solidly built grazers that stand 3.5 (1 meter) tall at the shoulder. Their coats are tan with a white rump.

The clincher for identifying bighorns, though, are the heavy wraparound horns. Ewes (females) have spike horns that are flattish and curl in a quarter to a half circle. Rams (males) have horns that start as a spike when they are yearlings and continue to grow thicker and heavier as they age. By seven to eight years of age, rams' horns can spiral around a full curl. At this point, the horns can weigh as much as all the other bones in the sheep's body put together. The horns develop a groove as their growth slows each winter, which makes it easy to find out how old a bighorn is—just count the grooves!

During mating season, bighorns race at each other at fifty miles per hour before crashing into each other's horns. Their skulls have shock-absorbing structures in them that keep the sheep from giving themselves fatal head injuries.

Bighorn sheep live on rocky outcrops and cliffs from desert to tundra. They have spongy pads on the bottom of their hooves that work like suction cups to hold them on impossibly steep rock faces. In winter, bighorns prefer windswept outcrops where hurricane-force gusts have cleared the snow from the previous year's plant growth. They often come down to the highways to lick the salt from the roads. Bighorn sheep are diurnal (active during the day). Would you want to be climbing cliffs in the dark?

If young bighorns can keep from falling or being preyed upon by coyotes, mountain lions or Golden Eagles in the first year, they can live to be twenty years old. As adults, diseases, including parasites like liver flukes or lungworms and associated pneumonia, take a heavy toll. Avalanches are deadly at any age.

Colorado has the largest population of bighorns in the world. Half of the state's bighorns live in the mountains on the east side of the Continental Divide.

Bighorn sheep are the Colorado state mammal.

Rodents

Small plant-eating rodents are at the bottom of the food chain. The survival strategy of these species is usually to grow fast, breed lots and die young. They often have several litters in one season, but few of the young live to adulthood. Those that do survive rarely live more than three years.

Chipmunks have stripes on their faces. *Courtesy Dick Vogel.*

CHIPMUNKS

Most people know chipmunks from roadside stops in the mountains, where the small rodents dash across open ground with their tails up, begging for handouts. They bark a high-pitched *chip* to stay in contact with one another.

You can tell chipmunks from ground squirrels because chipmunks have a pattern of light and dark stripes from their noses down their backs; ground squirrels don't have the lines on their heads.

The word *chipmunk* may come from the Algonkian word for "head first," which is how chipmunks (and most tree-climbing animals) come down a tree. But chipmunks actually spend much of their day on the ground, digging tunnels and caching seeds and berries that they've found.

GOLDEN-MANTLED GROUND SQUIRRELS

Golden-mantled ground squirrels are larger than chipmunks and have no stripes on their heads. Their stripes start after the tan to russet collar or "mantle" on their shoulders.

The stripes on golden-mantled ground squirrels only start after their golden mantles on their shoulders. *Courtesy the author.*

True to their name, ground squirrels live mostly on the ground, especially among rocks near forest edges or meadows. They range from the subalpine to the High Plains. Like chipmunks, they live in burrows. Ground squirrels eat leaves, stems, seeds and berries, as well as eggs, fungi and carrion. Again like chipmunks, they are big beggars.

Yellow-Bellied Marmots

The yellow-bellied marmot does indeed have a yellowish or orangish belly, with a brown back, a gray-tipped, bushy tail and short ears. Marmots are the biggest squirrel in the Rocky Mountains—about 2 feet long (0.6 meter).

Marmots range from the valleys to the tundra and from British Columbia to New Mexico and east to the Black Hills of South Dakota. They always live in open areas among large rocks. Marmots' lives among the rocks give them the nickname of "rock chuck"; their whistle-like chirp earns them the moniker "whistle pig."

In the summer, these giant squirrels have a set pattern to their day: They are up at dawn foraging. They prefer to eat "forbs" (plants that don't have woody stems) but also eat grasses, sedges and leaves of shrubs. A lot of marmots are killed when predators attack them from ambush. Marmots therefore prefer to forage in open areas, so that they can see trouble coming.

Midmorning, they stop and bask in the sun. Then they go back to foraging around noon. Midafternoon, they have another bask and then forage until dusk, when they return to their burrows. All this foraging gives them fat to help withstand their winter hibernation.

To survive the winter hibernation, marmots also have to have good dens. Competition for the best den sites is strong. In fact, the number of good hibernation sites probably is the factor that limits the size of many marmot populations.

Once they find a good site, they line their nests with grasses that they've gathered. In September or early October, they go into their dens to hibernate. If they survive, marmots come out of their winter dens in April or May.

A marmot colony is made up of a single adult male that keeps a harem of females and their yearlings and young. The yearlings are eventually forced out. When that happens, they are very vulnerable because they don't have the protection of others in the colony looking out for them. Coyotes, foxes, badgers, martens, weasels, Golden Eagles and black bears can easily catch lone marmots.

BEAVER

Beaver are the exception to the general rodent model. They are the largest rodent in North America, with bodies 3 feet long with another foot (0.9 meters plus 0.3 meters) of tail and weighing up to 55 pounds (25 kilograms). They can live up to nineteen years in colonies of extended families, which begin with a pair, their yearlings and their single litter of three to five young kits a year.

Beaver are dark brown above and golden brown beneath, with a flat, naked, scaly tail. Their front teeth are orange, probably from the inner bark of the willows that they chew. A beaver is constantly gnawing on wood, so these teeth are constantly growing. The reverse is true, too. If a beaver doesn't constantly wear its teeth down by chewing, they can grow until they wedge the beaver's mouth open, and it starves to death.

These giant rodents are very well adapted to life in the water: their coats are waterproofed with an oil secreted from glands, they have thin layers of fat to keep them warm in water and they have clear membranes that slide over their eyes to protect them while swimming. Their most unusual feature may be that their lips form a seal *behind* their front teeth. This lets beaver chew on wood while they are under water, without mud and chips entering their mouths.

Beaver are nocturnal, which is their only protection when they waddle onto land to cut down trees. When they are threatened while in the water, they give a slap of their flat, scaly tails to warn others in the colony as they dive to safety.

It surprises many people to learn that beaver do not eat the wood of the trees that they cut down. Instead, they feed on grasses and forbs in summer. For winter, they cut down aspen, willow and alder and then trim off the branches and store them under water. They eat the leaves, buds, bark and twigs of the submerged branches in winter. In a pinch, beaver will eat wild cherry, serviceberry or mountain mahogany.

One of the best ways for you to know that beaver are around is to see gnawed tree stumps. It takes a beaver about thirty minutes to fell a 5-inch-diameter (.13-meter) tree; a single beaver may cut down 1,700 trees *each year*.

Instinct drives beaver to dam running water wherever there are suitable plants—particularly aspen, willow, alder and birch—to use for their building jobs. In the water, a beaver can pull a 20-pound (9.1-kilogram) branch in its teeth. They use this strength to build dams of mud, branches and sticks up to 14 feet high and 3,000 feet long (4.3 meters and 914.4 meters).

The dams create a pond 6 to 8 feet (1.8 meters to 2.4 meters) deep. This is deep enough that the water creates a moat around the lodge and, in winter, lets beaver swim beneath the ice to get to their caches of branches. Beaver lodges are cone-shaped piles of more mud and sticks. First they make a mound of mud topped by sticks about 6 feet high and 15 feet across (1.8 meters by 4.6 meters). Then they dive under the water to dig a tunnel through the mud and hollow out the pile of sticks from the inside to form a den.

In a happy coincidence for beaver, their favorite foods—willows, aspen, cottonwoods and alder—do well in moist to wet soils. Many other trees, such as most evergreen conifers, die in the constant wetness. The ponds create a favorable habitat for fish, muskrats, mink and waterfowl, too.

The silt and dead plants carried by the stream settle out when they drift to the still waters of the pond, slowly filling it. When the pond becomes too shallow, the beaver move on. Eventually, these rich soil particles will fill the pond, and it will become a meadow.

Rabbit Relatives

Rabbits, hares and their relatives, pika, have molars that don't line up directly. They have to chew from side to side, which gives them a distinctive look when eating.

Pika

At first, it's hard to see that pika are relatives of rabbits and hares. Instead, pika look like a grayish hamster, with short round ears and a stub of a tail. And pika run instead of hopping, like a rabbit or hare. But there is still something vaguely rabbitish about pika.

Very little is known about pika, but what we do know is fascinating. Pika are restricted to mountain "talus" (big broken rock) slopes, mostly in the tundra, but the little animals may wander down to the spruce-fir or even ponderosa forests if they can find a rock slide or old mine tailings for a suitable home. The rocks must be big enough to form open spaces under them, where pika can make their nests.

In the short summer, industrious pika gather plants to make a haystack in front of their burrows. The haystacks may hold a bushel or two of hay. The pika will use the hay in the winter months, lining their nests among the rocks with some of the hay and eating the rest.

Pika often nest where the snow builds up. Then they dig tunnels up to 100 yards (91 meters) long under the snow, going from their dens to their forage areas. By digging the dens under the snow, the pika are protected from the bitter cold and blasting winds that animals on the surface must endure.

The word *pika* is pronounced "pee-kuh" by purists. The name either comes from a Siberian dialect or from their *peeka* alarm call. Weasels, martins, coyotes and hawks all will cause the little rabbit relatives to cry *peeka*!

Carnivores

Carnivores are those animals that mainly eat meat. This includes foxes, coyotes, wolves, mountain lions and black bears. Carnivores are, by definition, predators—they hunt other animals for food. But many carnivores eat some plants as well. When they mix meat and plant foods, they are omnivores.

Canines

Native Colorado canines include coyotes, wolves and foxes. Coyotes are the size of medium dogs but have longer legs. Their coats are tan to red-brown, with black guard hairs that break up their solid color. Their tails have black tips. Coyotes carry their tails down and, when frightened, between their legs.

Wolves, by contrast, are larger, heavier animals that carry their tails straight out or up. Foxes are smaller and redder than coyotes and have a white-tipped tail. Coyotes might be confused with a German Shepherd, but the dogs have shorter legs and larger foreheads and carry their tails straight out.

Wolves
There are currently no breeding populations of wolves in Colorado, and there are no plans to reintroduce them. If wolves come in on their own, though, they would be protected by the Endangered Species Act. As of 2015, there have been wolf sightings in North Park and near Idaho Springs.

Coyotes

Coyotes are the fastest living land predators in North America. They have a top speed of 35 to 40 miles per hour and they can lope for long distances at 25 to 30 miles per hour.

Coyotes usually hunt alone or in pairs, taking mostly rodents and rabbits. They will sometimes pack up to take larger prey, including deer, bighorns, sheep, calves and cats and dogs. Because coyotes eat carrion (dead animals), they probably get blamed for killing animals that die of other causes. In fact, although coyotes prefer meat, they will consume almost anything they find, including trash, vegetables and berries, which explains why they are so successful.

With the extinction of wolves throughout much of the United States, the range of coyotes has expanded to include all of Colorado and almost all of North America, except the far northern tundra and the southeast U.S. forests. Wolves and coyotes do not share territory; wolves will drive the coyotes out.

Coyotes have gotten bolder over the last decade or two, moving into cities to feed on rodents, trash, cats and small dogs. There have even been rare incidents where coyotes have attacked people. They interbreed readily with dogs and can produce some "coydog" hybrids that may approach the size of wolves.

The name coyote is from the *Nahuatl* (Aztec) word *coyotl* (pronounced "koy-OH-tehl"). There are two different ways to pronounce "coyote." In New Mexico and Arizona, they pronounce it "kai-OAT-ay." To the north, including most of Colorado, we pronounce the word "KAI-oat," dropping the last "ay" sound. Either pronunciation is okay.

Canis latrans, the scientific name for a coyote, means "barking dog." The yipping howl often used in movies to represent wolves is, in fact, a coyote. Wolf howls are much more song-like, without the yips.

"Coyote" or "Old Man Coyote" appears in the myths of many North American tribes. Sometimes he is the hero of the story and sometimes the trickster. Sometimes Coyote just causes trouble. Coyotes have made it into pop culture through the cartoon character Wile E. Coyote and in southwestern art. In German, coyote translates as *steppenwolf*, or "wolf of the steppes or prairies."

Felines

Colorado cats include bobcats and lynx, but in Rocky Mountain National Park, the mountain lion is the only cat. Although Rocky Mountain National

Park has excellent habitat for the Canada lynx, currently there are no known lynx in the park.

MOUNTAIN LIONS

Chances are that you'll never see a mountain lion in the wild—few people do. They do their best to stay out of sight when humans are around, so if you see one, it is a very rare experience.

Female mountain lions are about 6 feet long and 60 to 100 pounds (1.8 meters, 27 to 45 kilograms); males are 8 feet long and 140 pounds (2.4 meters, 63.5 kilograms). Their tails make up 30 to 40 percent of their total length. Only lions, tigers and jaguars are bigger cats. In spite of this, mountain lions are classed as "small cats" because they cannot roar. Instead, they scream. They are also the largest cats able to purr. In Colorado, mountain lions are solid grayish to reddish brown, with white bellies. Elsewhere, they can be tawny to gray to cinnamon.

Mountain lions are a bit of an oddity. They have one style of hunting—leaping from ambush—and they do it extremely well. Their bodies are very specialized for this type of hunting, to the point that they can't run all that well.

A mountain lion's collarbone and front limbs are so specialized for absorbing the impact from great leaps that, although it can bound along for

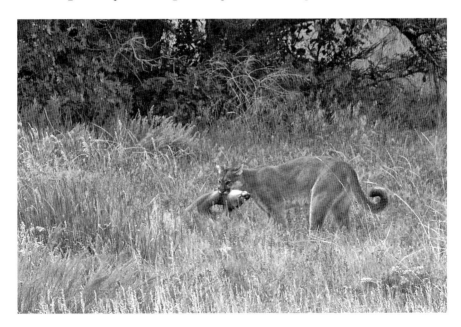

Mountain lions hunt from ambush. In the Rocky Mountains, mule deer are their favorite prey. *Courtesy Dick Vogel.*

40 yards (36.5 meters) or more, it can't run very fast for very long. Mountain lions also have the biggest thighs of any cat. The cats need muscular hind legs in order to make their huge leaps for a kill.

To hunt, the cats glide from trees to rocks to shrubs, avoiding open areas. They silently slip into a preferred ambush spot next to or above a game trail and then wait, motionless but for the flicking of their tails. When a deer walks by, the cats leap, killing the prey with the force of the jump itself or a bite to the neck. Their huge thighs allow mountain lions to drag their kills up trees or jump up to rock ledges so that the cats can eat their meal without being disturbed. They are one of the few big predators to cache the leftovers.

Usually in nature, when you have an animal that is very specialized, it has a very restricted habitat. Not so for the mountain lion. It has the biggest range of any mammal in the Western Hemisphere. The mountain lion's range stretches from British Columbia to Argentina, from sea level to 14,000 feet (4,267 meters). Because they live over such a wide area, mountain lions go by a bunch of different names—"puma" comes from the Incas; "cougar" comes from Brazil; and "catamount," "panther" and many others come from elsewhere in the Americas.

The mountain lion's success over the Western Hemisphere depends on two things: it can use almost any type of cover, and it will eat anything that moves. Mule deer are a mountain lion's primary prey in Colorado, but as long as it's meat, the cats will eat it—elk, bighorn, horses and rabbits. In South America, they eat capybaras (plant-eating rodents the size of small pigs), mice and birds.

In the Rockies, the cats live mainly in the mountain shrub and ponderosa pine communities. In Colorado, they are most abundant in the broken country of the south and west, where there is plenty of good cover for ambushes. Mountain lions roam over very large ranges—20 to 500 square miles (52 to 650 square kilometers).

Omnivores

One hundred years ago, Colorado had two types of bears: grizzly and black. Grizzly bears are bigger than black bears, with a hump over their shoulders and a "dished-in" face. Black bears are smaller, with a flatter back and face. Black bears also need a smaller range and are more adaptable to human presence; they've survived in Colorado, while grizzlies are no longer here.

Grizzly Bears

We currently have no grizzly bears in the state. Given the huge territories that grizzlies need and their unpredictable nature, there are no plans to reintroduce any in the future.

Black Bears

If you see a bear in Colorado, it is a black bear, even if it is brown, cinnamon or blond. The color of the bear's fur doesn't matter. Black bears are 4.5 to 6 feet (1.4 to 1.8 meters) long, 3 feet (0.9 meters) high at the shoulder and weigh up to 600 pounds (272 kilograms). They have long, strong claws for digging up much of their food.

As omnivores, black bears eat anything they find—berries, plant leaves, carrion, insects, eggs, honey, baby animals and trash. They don't usually

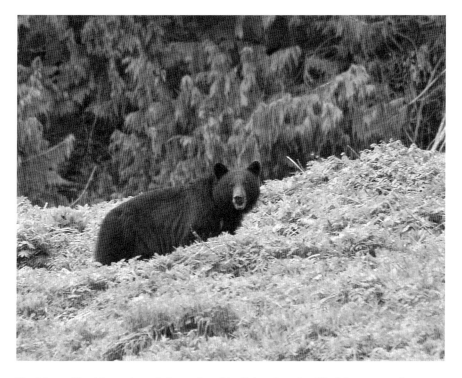

Black bears like this are the only bears found in Colorado today. Black bears come in tan, cinnamon and black color variations. *Courtesy the author.*

hunt larger animals, but a sow and her cubs may take young moose, mule deer or elk.

About 95 percent of a black bear's diet is plants. They have developed a love of dandelions along roadsides, digging furrows of them up with the long claws on their short, powerful legs. Their passion for the yellow weeds sometimes leads to collisions with cars.

Bears may visit camping spots or trash cans to get easy treats. If they get used to these handouts, they start thinking that it is their right to eat from your campsite. When that happens, the bear has to be killed. If you are camping out, make sure that you bear-proof your camp. A fed bear is a dead bear.

A black bear may have a range from 10 to 250 square miles (26 to 650 square kilometers). In Rocky Mountain National Park, they range all over, from ponderosa savannas through spruce-fir up to the tundra. If you do encounter a bear on the trail or in your yard, let them retreat or you back out slowly. In a one-on-one fight, you're not likely to come out well. Most of the time, though, bears avoid people. They will sense your presence and skedaddle long before you see them.

The most visible signs of bears that you may see are claw marks on aspen trees, made as high up as a bear can reach. These scratches may mark a bear's territory. But don't be fooled—elk and mule deer also thrash against aspen, trying to rub the velvet off their antlers. Bear marks are head level or a little above, parallel to one another and often somewhat curved.

Bears have always held a lot of symbolism for people, probably because they resemble us in several ways—they can stand on two legs, they are smart and they are omnivores. People have feared and revered bears from prehistoric times to today. Bears are the national animal of Russia, and the black bear is the state animal of New Mexico.

Birds

Birds are some of the most visible animals that you'll see in Rocky Mountain National Park. Here, I've only discussed some of the birds that you're most likely to spot.

Birds of Prey

Raptors are meat-eating birds such as eagles, hawks, falcons, vultures and owls. They are also called birds of prey or hunters of the sky. Raptors have a truly awesome arsenal at their disposal for hunting and eating their prey. All have large, powerful, sharp claws called talons for catching and holding their prey. All have hooked, razor-sharp beaks for tearing up carcasses. All have excellent eyesight, generally about ten times better than that of humans (and we have good eyesight compared with most of the rest of the animal kingdom). All have long, flexible tails that help them turn quickly when they are pursuing prey.

When trying to identify raptors, be sure to use all the clues that you have: what they look like, where you saw them and at what time of the day. Don't be afraid to go with your gut instinct; often you are using clues you didn't even know you had picked up. You'll get better with practice. It may be tough, but when you realize that you have just seen a hawk with its prey in its talons, it is a real thrill.

The only real threat to most raptors is humans. Raptors have often been hunted by ranchers for killing livestock. Pesticides, especially DDT, threatened raptors in the later half of the 1900s by getting into the food chain. The pesticide changed the reproductive cycle of raptors and caused them to lay eggs with such thin shells that they cracked when their parents roosted on them, killing the chick inside. A ban on DDT and protection for many species under the Endangered Species Act has allowed raptors to rebound so that you see more of these birds today than you did thirty years ago. Today, it is development that threatens many raptor hunting or nesting sites.

Eagles

Eagles are the largest birds in Colorado. In fact, in North America, only the California Condor is larger. Eagles can be recognized in flight because they are very large birds that hold their wings as flat as an ironing board when soaring.

Bald Eagles

Bald Eagles are big, dark birds—2 to 3 feet (71 to 96 centimeters) tall, with a wingspan of up to 8 feet (244 centimeters). They have white heads and

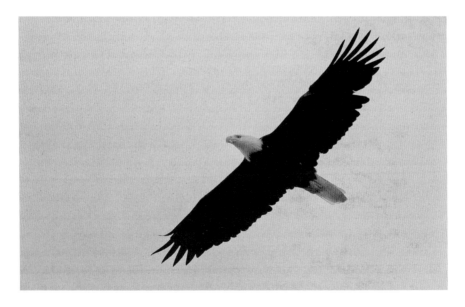

Eagles soar with their wings flat. *Courtesy Dick Vogel.*

tails and yellow bills and legs. In spite of their status as our national symbol, Bald Eagles nearly became extinct in the lower forty-eight states in the1970s. Ranchers had long hunted and poisoned them as predators of lambs and calves. DDT prevented eggs from surviving. Loss of habitat around lakes and rivers reduced the number of good nesting sites.

The good news is that Balds are making a comeback across the United States. A ban on DDT in the United States and protection under the Endangered Species Act have brought Bald Eagles back from the brink of extinction, listed now as "Threatened," instead of passing into a nostalgic memory.

Each nesting season, balds reuse the same 4- to 5-foot-diameter (1.2- to 1.5-meter) nest, sometimes for years. They build their enormous nests in huge cottonwoods or pines or on rock ledges. In 1995, there were thirty-three breeding pairs in Colorado. In 2011, there were forty to fifty. Balds are very sensitive to human disturbances during nesting, so don't approach the nests in spring or summer.

Although they eat just about any animal, dead or alive, Bald Eagles hang out near open water in search of their favorite foods: fish and waterfowl. Therefore, your best chance of seeing a Bald Eagle is near a large body of water. Lake Estes, Grand Lake, Shadow Mountain Reservoir and Lake Granby are all good places to look for Balds. The Colorado, Fall and Big Thompson Rivers lure them in occasionally as well.

Because they are fishing eagles, Bald Eagles don't have feathers on their legs because these feathers would constantly get wet, weighing the bird down. Balds either fly over the water and "stoop" (drop) when they see a fish, or they sit in trees until something comes within range and then drop on it. You might see several Balds perched in the same tree along the shore of a wetland, waiting for their chance to pounce on some hapless creature below. Often Balds will steal a meal from Ferruginous Hawks or Ospreys rather than catch their own food.

Golden Eagles

Golden Eagles get their name from a golden sheen on the feathers on the nape of their necks. They are big brown birds; the only birds bigger in Colorado are Bald Eagles. Like Balds, they hold their wings out flat when they soar.

Your best place to see Goldens is in hilly, open country with trees nearby for perching and in pine forests. In Rocky Mountain National Park, that means the ponderosa savannas and meadows, glacial canyons and the tundra above timberline.

As with many raptors, Goldens nest in cliffs, another reason why they like the mountains. They use the same nest for generations, adding new sticks each year.

These eagles hunt rabbits, rodents and the occasional wading bird by flying low over the ground before popping over a rise to surprise their prey. The big raptors need vast areas for hunting to survive. During the spring and summer nesting season, Goldens concentrate in the northwest corner of Colorado, where there are lots of rabbits. The more rabbits to hunt, the more baby eagles survive.

In winter, Goldens spread out statewide and turn to scavenging, especially roadkill. True to the scavenger credo, they gorge themselves until they are unable to fly. At that point, they are in danger of becoming highway casualties themselves. Other threats such as electrocution from power lines, shootings and poisonings haven't noticeably affected the numbers of Goldens in Colorado.

The feathers of Golden Eagles were highly prized by many Indian tribes. For the Plains tribes, the black-tipped white tail feathers of immature (able to fly but not yet adult) Goldens were used to signify brave deeds in battle. Each feather in a headdress or in the hair was awarded for a specific deed, similar to our military awarding medals for bravery.

To fly, birds must have the same number of flight feathers on each wing for balance. (This is why you can ground a bird by clipping one wing's feathers.) Add to that the fact that Golden Eagles mate for life, and you can easily understand why, in many tribes, a pair of matching Golden Eagle wing feathers held the same significance as a wedding band in European cultures. The meaning was unmistakable: *Without you, I can't fly.*

The stature of Golden Eagles extends to other cultures and across history. In Europe, the Roman Legions used to carry a figure of a Golden Eagle on top of their standards. In the Middle Ages, only emperors were allowed to hunt with eagles.

Hawks

Hawks are smaller than eagles. While eagles hold their wings flat when they soar, hawks hold their wings in a shallow *V* shape.

Red-Tailed Hawks
Red-tailed Hawks are the most common hawks you will see in the western United States. They are large, broad-winged hawks with broad red tails that

fan out wide, creating the illusion that they are "all wings." When they soar, they hold their wings in a shallow *V* shape. Usually, Red-tails are dark on their upper side and heads and light-colored on their undersides. They have a band of darker feathers on their bellies, dark trailing edges of their wings and dark "commas" on their wings.

Red-tails live in more habitats than any other hawk in North America. In Colorado, they are year-round residents of open country and forests. Red-tails thrive in open areas interspersed with elevated perches like trees and cliffs. This pretty much covers Rocky Mountain National Park. Fire suppression may have increased the numbers of Red-tails in Colorado mountains by providing more perches.

Adaptable Red-tails use these perches to swoop down on anything smaller than they are. Their favorite foods are rodents, rabbits, birds and snakes.

You have probably heard the Red-tail's cry. In the movies, the screaming *kreee* of the Red-tail is often used to signify any bird of prey or to symbolize the wildness of an area. They use the Red-tail cry because it is one of the few raptors to make any noise.

Jays, Crows and Ravens

Crows, Ravens and jays (including Magpies and Nutcrackers) are some of the most visible birds in Rocky Mountain National Park. They also all belong to the same family of birds: corvids.

A hallmark of the corvid family is that they are omnivores—they eat almost anything. They cache much of the food they find, usually by burying. They have a pouch under their tongue that lets them haul dozens of seeds at one time to be cached. The birds may make thousands of caches to be found later. It may be just a few minutes later or up to a year, but their memory for where they hid the caches is remarkable.

Most of these birds are very comfortable around humans and so will show themselves or even steal food from your picnic table. Don't encourage them.

Although they may be great mimics, no corvid has a beautiful song. Instead, they have a very wide variety of calls for a wide variety of situations. Most of the calls are described as rasping, grating and hoarse.

Another common characteristic among Colorado corvids is that they nest early, often while there is still snow on the ground. Many are cooperative

breeders, meaning that young or siblings help out at the nest to raise the next brood of birds.

Finally, corvids are smart. The theory is that animals that are generalists and social have to be smart in order to remember what food is edible, where to find it, where they hid it and who might steal it. Jays are smart for birds, but by the time you get to Ravens, they approach the same level as dolphins, chimps and elephants. They recognize themselves in the mirror, they play, they plan, they deceive and they use tools.

Jays

In the Dark Ages (before the age of television), nobles used to entertain one another by making up words for groups of animals: a "parliament" of owls, a "rook" of Ravens, a "murder" of Crows. I don't know if the nobles had a collective name for a group of jays, but the way the birds quarrel when an extended family of them flies from tree to tree, they should be called a "dysfunction" of jays.

Most of the jays discussed here—Clark's Nutcrackers, Gray Jays, Steller's Jays and Magpies—are a little bigger than a Robin but a little smaller than a Crow.

CLARK'S NUTCRACKERS

Clark's Nutcrackers live in conifer forests from timberline to piñon-juniper, even into aspen and shrub lands. Nutcrackers are a bit bigger than a Robin; gray with black wings and tail; white markings on head, wings and tail; and a long, slender, pointed bill. They use a crow-like "rowing" flight for long distances and a woodpecker-like "flap flap glide" for shorter ones.

True to their name, Clark's Nutcrackers eat mostly nuts and seeds. Their long, pointed bills are especially useful in opening unripe limber, bristlecone and ponderosa pine cones, giving them a different niche from other jays. They carry seeds in a "sublingual" (under the tongue) pouch. In winter, Nutcrackers dig through the snow to find nut caches that they hid in the fall. The birds find the caches two out of three times they try. Being corvids, Nutcrackers also eat insects, carrion and small animals. Nutcrackers can be very insistent beggars at campgrounds.

GRAY JAYS

A little larger than Robins, Gray Jays have dark-gray heads, backs and wings; light-gray breasts; and white foreheads and necks. Their thin bills and legs are black. Gray Jays are usually silent.

Gray Jays live in spruce-fir and lodgepole forests right up to the krummholz at timberline, higher up than any other jays. Their range stretches from the high country of northern New Mexico and southern Colorado into Canada.

Several characteristics make Gray Jays unique. First, they eat very few nuts but instead use their needle-like beaks to eat berries, small animals, insects and mushrooms (including some that humans find poisonous or hallucinogenic). Next, they make food balls with saliva and stick them onto the bark of trees or underneath pine needles to cache them. Gray Jays make up to one thousand caches. They find most of them, sometimes up to a year later. Finally, they carry heavier stuff in their feet. Most other birds (except raptors) carry everything in their beaks.

The Algonkian Cree people of Canada called Gray Jays *wiss ca chan*, which was Americanized to "whiskey jack." They are also known as "Canada Jay" or "Camp Robber." The Camp Robber name came from their boldness in begging for handouts. They will steal anything edible from a campsite, sometimes walking right into a tent.

Steller's Jays

Steller's Jays are one of two crested jays in Colorado (the other being that recent immigrant, the Blue Jay). Steller's are indigo blue with a white eyebrow and a black breast and crest. The crest goes up when the bird is angry. They announce their arrival with a loud *shak shak shak* cry.

You can find Steller's Jays in a broader range of habitats than any other jay. Steller's prefer ponderosa and Douglas-fir forests but also live in spruce-fir, piñon-juniper, lodgepole and even aspen—anywhere from the foothills to the lower elevations of the mountains. This puts them in the broad niche between Gray Jays of the spruce-fir forest and Blue and Pinyon Jays of mountain shrub and piñon-juniper communities.

More of a generalist than most jays, Steller's eat mostly insects and other small animals in the summer; in winter, they switch to seeds and berries. You'll often see them on the forest floor, rummaging through the plant litter. Like other corvids, they cache food.

A little shyer than the others, Steller's Jays still become used to people very quickly. The adaptable jays are doing well as people build homes and put up bird feeders in the ponderosa savanna and lodgepole pine forests.

MAGPIES

Magpies are striking, iridescent black-and-white birds with very long tails. A Magpie flies in a series of "J-swoops," weighted down by its tail trailing behind. Although the tail makes flying awkward, it lets a Magpie change direction instantly. They are very smart birds and have a hoarse *cha cra cra cra* call. You won't mistake them for anything else.

These black-and-white jays live across the western United States, in Europe and in Asia—anyplace that is dry and cool. In Colorado, Magpies prefer nesting in scattered trees in open country from the plains to the krummholz.

Magpies do very well near people, eating garbage, dog food and anything else they can find. When they aren't around humans, they eat small mammals, carrion and the fly maggots it produces and other insects, especially grasshoppers. Since most Magpie food is perishable, they hoard it for only short periods of time.

Crows and Ravens

Crows and Ravens have ranges in North America, Europe and Asia; they show up often in mythologies from around the world. In American Indian mythologies, Raven is involved with the creation of humans. In ancient Norse mythology, Ravens are the messengers and informants of Odin, king of the gods. Aesop talks about Crows' ability to reason. In all mythologies, Ravens and Crows are noted for their intelligence, often shown in their ability to plan and play. This is because both species of birds are amazingly smart, using tools to get what they want and plan how to fool others.

I once had someone ask me why we in the West call medium-sized black birds "Ravens" when in the East they call them "Crows." The answer is that in the West, they probably *are* Ravens, and in the East, they are more likely to be Crows. But my friend had a point. Both are larger-than-most, jet-black birds. How do you tell them apart?

AMERICAN CROWS

Crows love humans. They love our farm fields, they love our backyards and they love our dumpsters. They love to nest in the same savanna environment that we create—trees scattered around but not dense forest. As we have modified the environment, Crows have expanded their range.

Black all over, with a square tail and medium-weight beak, Crows are, well, Crow-sized. It's an indication of how common they are that we use them to compare with other birds. Consummate generalists, Crows eat

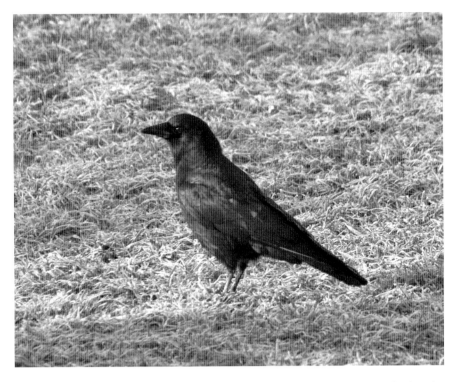

Crows are smaller, sleeker and more social than ravens. They also have a smaller beak and a square tail. *Courtesy the author.*

almost anything—small animals but also seeds, insects and carrion. Around humans, they indulge in garbage, dog food or birdseed.

Crows are very social birds—much more so than Ravens. Crow flocks often have up to thirty birds but sometimes over one thousand. Although Ravens may be better problem-solvers, Crows may have better social intelligence. Out of one thousand black-feathered individuals, they can find their mate and recent offspring. And out of thousands of people on a college campus, Crows can recognize the one human who once caught them for research and stay just out of reach of that person, screaming at him all the while.

COMMON RAVENS

Common Ravens are larger than American Crows; in fact, they are the largest perching birds in the world. They have a heavier beak and puff up a ruff of coarse feathers at their throats when annoyed. A Raven's call is usually a deep rough croak, although they have thirty or more calls that they

135

Ravens are big black birds with heavy beaks and V-shaped tails. *Courtesy the author.*

use. *Corax*—in the Raven's scientific name, *Corvus corax*—means "a croaker." Ravens prefer to soar, flapping up and down only when they have to.

Although they live from Mexico north to the Arctic and into Europe and Asia, Ravens are found in areas without many people, of which there are more in the West. These adaptable birds are found in every environment from deserts to tundra, any place they can build a nest off the ground. In Colorado, they nest in conifer forests and cliffs more than any other habitat, especially at higher elevations.

Omnivorous scavengers, Ravens prefer carrion but will eat anything. They have been known to lead wolves to a fresh carcass so that the wolves can rip through the tough skin. When the wolves are finished, the Ravens feast on the leftovers.

Ravens are very smart birds, approaching the intelligence of chimps and dolphins. Not only do they make caches, but they also move them when other Ravens aren't looking so that the caches aren't raided. They use sticks to fish insects out of holes. And they can figure out a complex series of steps required to get a choice piece of meat.

Ravens often indulge in some fancy flying, diving and rolling, even flying upside down for a half a mile. These displays may be for dominance within a group or for courtship displays. But sometimes it's just play, another hallmark of intelligent species.

Chapter 12

FOREST FIRES

FIRE IN FORESTS

Fire is a natural part of some forest ecosystems. To stay healthy, many western forests must burn on a regular basis. In fact, over the last five hundred years, most forests in Rocky Mountain National Park have burned at least once.

Ponderosa and Douglas-Fir Forest Fires

The lower in the mountains that you are, the more frequently the forests burn. Growing between 5,600 and 9,000 feet, both ponderosa pine and Douglas-fir trees are adapted to withstand light burns every five to sixty-six years. These fires create a loop: Frequent fast and light fires keep duff layers thin. Thin duff layers keep fires light and fast. When the cycle is disrupted, trees grow closer together and produce heavier layers of leaves, needles and fallen branches. This duff buildup can lead to catastrophic crown fires.

Lodgepole Forest Fires

As you go up in elevation, the climate gets progressively cooler and wetter. The wet, cool conditions mean that fires happen less often.

Lodgepole pine forests (between 8,000 and 10,000 feet) burn every 250 to 400 years. The longer between fires, the more fuel builds up, the hotter the fires eventually burn.

But hot fires aren't always a bad thing for lodgepole pines. Their cones are "serotinous" (glued shut with resin) and don't open when they first mature. These cones remain on the tree for years until they get really hot—some need temperatures up to 140°F (60°C) to melt the resin and release the seeds. The only time a lodgepole forest gets that hot is during a crown fire—the hottest, fastest-moving, most destructive of all forest fires. Cones in the heart of the fire burn, of course, but many others in cooler spots simply open up and drop their seeds.

Spruce-Fir Forest Fires

It takes three to four hundred years to build up a fuel load big enough to overcome the cool, moist conditions in the subalpine zone (between 8,500 and 11,500 feet). That means that Engelmann spruce–subalpine fir forests rarely burn. But when they do burn, it is usually as a crown fire that destroys much of the forest.

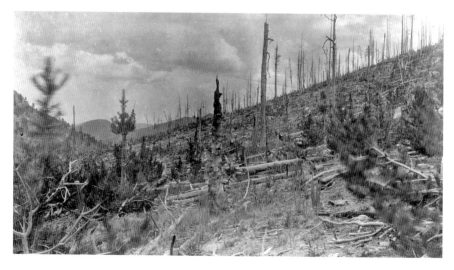

This forest in Rocky Mountain National Park burned as a destructive crown fire in 1900, sixteen years before the photo was taken. *Courtesy United States Geological Survey.*

NOT ALL FOREST FIRES ARE BAD

Few animals actually eat the needles, cones or bark of evergreen trees. Grazers and browsers like elk and deer prefer the grasses and shrubs that grow in the fire-created meadows. Not only that, but the juicy new growth that sprouts after a fire is full of nutrients.

The Utes and earlier people understood that animals preferred the new growth in burned areas. The people used fires to burn off old growth and create openings in the forest. The meadows provided better forage for animals. The more animals that came to the meadows, the more animals the Utes could hunt.

But the forests took a beating between 1860 and 1915, as miners came into the mountains. Forests were clear-cut for building mines and camps. Prospectors lit fires to clear duff—needles and other fine bits of vegetation—off the rocks; often the fires got away from them.

As people saw that they were losing their forests, they reacted by putting out forest fires. By the 1920s, the U.S. Forest Service, Bureau of Land Management and state agencies across the West were sending out thousands of forest firefighters. In the 1950s, the agencies began to use retired air force bombers and other air tanker airplanes to drop tons of a thick slurry of slippery pink fire retardant in front of fires to slow the fires' spread and helicopters to drop loads of water on hot spots. These fire crews helped to contain forest fires that burned throughout the West. The forests got denser, and trees spread onto grasslands. This was especially true in the ponderosa pine and Douglas-fir forests.

But putting out *every* forest fire turned out to be a bad idea. As trees grew closer together, they competed with one another for resources like sunlight, space, water and nutrients. Without something like fire to thin them out, many more trees grew, but they were smaller and weaker. Dead needles, branches and cones built up litter on the forest floor as well, becoming tinder for catastrophic crown fires later. Again, this was especially true in the ponderosa pine and Douglas-fir forests. Ironically, these are the forests best suited to withstand light ground fires.

Forest managers recognized the error of their ways in the 1980s. Many national forests and national parks instituted "let burn" and "controlled burn" policies. The idea is that smaller fires will thin out diseased and some younger trees. This will keep the canopy open, reduce the chances of a crown fire and create a healthier forest overall.

We're still learning about the finer points of fire in forests. While some forests have always had light burns to clear off deadwood, recent research suggests that devastating crown fires were normal long before we began to suppress fires, especially at higher elevations of lodgepole and spruce-fir forests. Thinning these dense, upper-elevation forests won't necessarily reduce the number of intense fires.

As it turns out, the weather is the biggest factor in deciding the severity of a fire. Hot, dry summers will generate greater numbers, bigger and more intense forest fires, regardless of whether the forests have been thinned or not.

Wildfire Fuel Types

Wildfires are classed by their fuel type. There are four types of forest fire fuels: ground, surface, ladder and crown.

Ground Fires

Ground fires are fed by ground fuels buried under the surface, such as roots, decaying needles and leaves (duff or detritus) and other organic matter. Forest fires or lightning often start ground fires, which can smolder for days to months. If they reach the surface, where there is plenty of oxygen, ground fires can flash into open flame. Ground fires are why a "contained" forest fire is never declared "out" until the cold and wet of the first major snowstorm sink into the ground to extinguish the last embers.

Surface Fires

Surface fires are comparatively slow and cool, as far as fires go. They are fueled by material on the soil surface—needles, leaf and timber litter, debris, grass and low-lying shrubbery. Usually surface fires clean up the forest floor and reduce the likelihood that future wildfires will grow into crown fires. This is the sort of fire that forest managers are trying for when they set a "controlled burn."

Ladder Fires

Ladder fires burn ladder fuels—materials that allow a fire to climb between surface fuels and overstory tree crowns. Ladder fuels are things such as small trees, standing dead trees and leaning logs. If trees are spread out so that the fire can't jump between them, ladder fires burn only sick or young trees, with few consequences to the forest at large. These small fires thin the forest to keep it healthy and create meadows that improve habitat for grazers. If, on the other hand, the trees are growing close together, ladder fires can lead to intense crown fires.

Crown Fires

If trees grow close together, the canopy or crown becomes closed (the tops of the trees overlap). When this happens, disease and insects can spread easily from tree to tree—crown fires can spread in a similar way.

Crown fuels are the treetop leaves, needles, twigs and branches. When a fire climbs ladder fuels into the canopy of a dense forest, it is called "crowning." Once in the canopy, crown fires burn hot and move fast, jumping from treetop to treetop. When wind or a hillside slope is added, crown fires are almost impossible to stop.

Crown fires are bad news for most forests. They kill everything in their path, leaving only smoking stumps behind. Healthy trees that might have survived a less intense fire are killed by crown fires. As these trees burn, their ability to hold the soil and provide seeds to replant the forest and food and shelter for forest critters goes up in flames.

Bibliography

Abbott, Carl, Stephen J. Leonard and David McComb. *Colorado: A History of the Centennial State*. 2nd ed. Boulder: Colorado Associated University Press, 1985.

Amman, Gene D., Mark D. McGregor and Robert E. Dolph. "Mountain Pine Beetle." *Forest Insect and Disease Leaflet 2*. USDA Forest Service, 1990. http://www.barkbeetles.org/mountain/fidl2.htm.

Armstrong, David Michael. *Rocky Mountain Mammals: A Handbook of Mammals of Rocky Mountain National Park and Vicinity*. 3rd ed. Boulder: University Press of Colorado, 2007.

Arps, Louisa Ward, Elinor Eppich Kingery and Hugh E. Kingery. *High Country Names: Rocky Mountain National Park and the Indian Peaks*. Rev. ed. Boulder, CO: Johnson Books, 1972.

Athearn, Robert. *The Coloradans*. 1st ed. Albuquerque: University of New Mexico Press, 1976.

Baillie, Kenneth, Alistair Simpson and A.A. Roger Thompson. "Altitude Air Pressure Calculator." Altitude.org, April 2010. http://www.altitude.org/air_pressure.php.

Bean, Luther E. *Land of the Blue Sky People*. 5th ed. Alamosa, CO: Ye Olde Print Shoppe, 1975.

Becker, Cynthia S., and P. David Smith. *Chipeta: Queen of the Utes—A Biography*. Montrose, CO: Western Reflections Publishing Company, 2003.

Bell, Katherine L., and L.C. Bliss. "Autecology of *Kobresia Bellardii*: Why Winter Snow Accumulation Limits Local Distribution." *Ecological Monographs* 49, no. 4 (1979): 377–402. doi:10.2307/1942469.

Benedict, James B. "Along the Great Divide: PaleoIndian Archeology of the Colorado Front Range." In *Ice Age Hunters of the Rockies*. Niwot: Denver Museum of Natural History; University Press of Colorado, 1992.

Boarman, William I., and Bernd Heinrich. "Common Raven (*Corvus corax*)." The Birds of North America Online. Edited by A. Poole. Cornell Lab of Ornithology, 1999. Retrieved from the Birds of North America Online, http://bna.birds.cornell.edu/bna/species/476. doi:10.2173/bna.476.

Bright, William. *Colorado Place Names*. Boulder, CO: Johnson Books, 1993.

Butler, Bill. "Rocky Mountain National Park—Archeological Sites." U.S. National Park Service, July 25, 2006. http://www.nps.gov/romo/historyculture/archeology.htm.

Canyons, Culture and Environmental Change. "Wildfire History and Ecology on the Colorado Plateau." Land Use History of North America—Colorado Plateau. Modified December 4, 2014. http://cpluhna.nau.edu/Biota/wildfire.htm.

Carlson, Paul. *The Plains Indians*. 1st ed. College Station: Texas A&M University Press, 1998.

Carter, Jack. *Trees and Shrubs of Colorado*. Silver City, NM: Mimbres Publishing, 2006.

Cassells, E. Steve. *The Archaeology of Colorado*. Rev. sub. Boulder, CO: Johnson Books, 1997.

Chronic, Halka, and Felicie Williams. *Roadside Geology of Colorado*. 2nd ed. Roadside Geology. Missoula, MT: Mountain Press Pub. Company, 2002.

Ciruli, Floyd. "The Buzz: Front Range Counties to Dominate Colorado's Population and Politics." The Buzz, March 23, 2011, modified November 16, 2014. http://fciruli.blogspot.com/2011/03/front-range-counties-to-dominate.html.

Colorado Bird Atlas Partnership and Colorado Wildlife Heritage Foundation. *Colorado Breeding Bird Atlas*. Denver, CO: self-published, 1998. Distributed by Colorado Wildlife Heritage Foundation.

Colorado Birding Trail. Colorado Department of Parks and Wildlife. Modified November 15, 2012. http://coloradobirdingtrail.com.

Colorado Department of Health and Environment. "Tipping the Scale." Colorado Department of Public Health and Environment, August 2000, modified January 16, 2012. https://www.colorado.gov/pacific/sites/default/files/PF_Tipping-the-Scales-Low-Birth-Weight-Problem-in-Colorado.pdf.

Colorado Department of Transportation. "Colorado Scenic and Historic Byways." http://www.coloradodot.info/travel/scenic-byways/north-central/trail-ridge-rd.

Colorado Division of Wildlife. "Gray Wolf." Mammals, January 31, 2010. http://wildlife.state.co.us/WildlifeSpecies/SpeciesOfConcern/Mammals/Pages/GrayWolf.aspx.

Colorado Foundation for Water Education. *Citizen's Guide to Colorado's Water Heritage*. Denver: Colorado Foundation for Water Education, 2004.

Colorado Geological Survey. "Extent of Glaciers in Colorado During the Last Ice Age." http://coloradogeologicalsurvey.org/colorado-geology/glacial-geology.

Colorado Geological Survey and Colorado Department of Natural Resources. *Messages in Stone: Colorado's Colorful Geology*. Denver, CO: self-published, 2003.

Colorado Natural Heritage Program, Colorado State University. "Rocky Mountain Lodgepole Pine Forest." 2005. http://www.cnhp.colostate.edu/download/projects/eco_systems/eco_systems.asp.

Colorado State Forest Service. "The Health of Colorado's Forests." 2010, modified January 16, 2012. http://csfs.colostate.edu/pdfs/105504_CSFS_09-Forest-Health_www.pdf.

Colorado State Forest Service—Colorado State University. "Forest Conditions." http://csfs.colostate.edu/pages/forest-conditions.html.

The Colorado 13ers. "CO 13er Peak List." http://www.13ers.com/peaks/13ers_all.php?displaytype=0&sublist=13ers&listd=list.

Colorado Water Conservation Board, Department of Natural Resources. "Water Supply Planning." Modified November 19, 2014. http://cwcb.state.co.us/water-management/water-supply-planning/Pages/main.aspx#WaterSupply.

Cox, John D. *Weather for Dummies*. Foster City, CA: IDG Books Worldwide, 2000.

Curtis, Rick. "OA Guide to High Altitude: Acclimatization and Illnesses." July 7, 1999. http://www.princeton.edu/~oa/safety/altitude.html.

Cushing, Bert. "Elk and Moose Exclusion Fence." National Park Service, U.S. Department of the Interior, 2010. http://www.nps.gov/romo/parkmgmt/upload/elk-fence.pdf.

———. "Fire History and Climate Change." National Park Service, U.S. Department of the Interior, 2008. http://www.nps.gov/romo/parkmgmt/upload/fire-history_climate-change.pdf.

———. "Stone Artifacts & Prehistoric Human Migration." March 2, 2008. http://www.nps.gov/romo/parkmgmt/upload/stone-artifacts.pdf.

Danter, Jeffrey. "An American Legacy." Wildland Fire, Fire Management Today, 2000, modified November 15, 2014. http://www.fs.fed.us/fire/fmt/fmt_pdfs/fmn60-3.pdf.

————. "Fire Dependant Ecosystems." Wildland Fire, National Interagency Fire Center. http://www.nifc.gov/preved/comm_guide/wildfire/fire_6.html.

David, G., and E. Wohl. "Biodisturbance in the Colorado Front Range." Warner College of Natural Resources, Colorado State University, 2011. Historical Variability of Valley Bottoms in the Colorado Front Range. http://warnercnr.colostate.edu/geo/front_range/biodist.php.

Denver Museum of Nature and Science. "Ancient Denvers." 2002. http://www.dmns.org/main/minisites/ancientDenvers/index.html.

Dickinson, Thomas. "Major Trans-Basin Diversions." Colorado Division of Water Resources, Office of the State Engineer, Colorado Water Conservation Board. http://sciencepolicy.colorado.edu/admin/publication_files/resource-647-wwa_map_3.pdf.

Dobson, G.B. "Mountain Men—Wyoming Tales and Trails." August 27, 2011. http://www.wyomingtalesandtrails.com/bridger3.html.

Doesken, Nolan, Roger A. Pielke Sr. and Odilia A.P. Bliss. "Climate of Colorado: Climatography of the United States No. 60." Colorado Climate Center, 2003. http://climate.colostate.edu/climateofcolorado.php.

Dunne, Pete, David Sibley and Clay Sutton. *Hawks in Flight: The Flight Identification of North American Migrant Raptors*. Boston: Houghton Mifflin, 1988.

Dunning, Harold Marion. *The History of the Trail Ridge Road*. Boulder CO: Johnson Publishing Company, 1971.

Erickson, Kenneth A., and Albert W. Smith. *Atlas of Colorado*. Boulder: Colorado Associated University Press, 1985.

Estes Park News. "Rocky Mountain National Park Offers Public Meetings on the Grand Ditch Breach Restoration Project." May 30, 2010. http://www.estesparknews.com/rocky-mountain-national-park-offers-public-meetings-on-the-grand-ditch-breach-restoration-project.

Federal Register. "Grand Ditch Breach Restoration Final Environmental Impact Statement, Record of Decision, Rocky Mountain National Park, Colorado." February 28, 2014. https://www.federalregister.gov/articles/2014/02/28/2014-04472/grand-ditch-breach-restoration-final-environmental-impact-statement-record-of-decision-rocky.

Finley, Bruce. "CU Fire Study of 8,000 Trees Finds Pre-Suppression Forests Burned Hot." *Denver Post*, September 23, 2014. http://www.denverpost.com/News/ci_26598092/CU-fire-study-of-8000-trees-finds-presuppression-forests-burned-hot.

————. "Hayman Fire, 10 Years Later: More Forests Being Allowed to Burn." Denver and the West. *Denver Post*, June 7, 2012. http://www.

denverpost.com/environment/ci_20800250/hayman-fire-10-years-later-more-forests-being.

————. "Northern Front Range Forests Among Prime Beetle-Kill Areas in 2010." *Denver Post*, January 22, 2011. http://www.denverpost.com/search/ci_17163793.

Fisher, Chris, Donald L. Pattie and Tamara Hartson. *Mammals of the Rocky Mountains*. Edmonton, Alberta: Lone Pine Pub., 2000.

Flint-Lacey, Patricia Robins. "The Ancestral Puebloans and Their Pinyon-Juniper Woodland." In *Ancient Pinyon-Juniper Woodlands: A Natural History of Mesa Verde Country*. Boulder: University Press of Colorado, 2003.

Fogelberg, Ben, and Steve Grinstead. *Walking into Colorado's Past: 50 Front Range History Hikes*. Englewood, CO: Westcliffe Publishers, 2006.

14ers.com—Home of Colorado's Fourteeners and High Peaks. http://14ers.com.

Foutz, Dell R. *Geology of Colorado Illustrated*. Grand Junction, CO: Your Geologist, Dell R. Foutz, 1994.

Geology.com—Geoscience News and Information. "Is Water a Mineral?—Is Ice a Mineral?" December 15, 2014. http://geology.com/artcles/water-mineral.

Glen Haven Historical Society. "Map of Dunraven's Buildings." http://www.ghhs.us/Map%20of%20Dunravens%20buildings.pdf.

Graham, Russel T., Sarah McCaffrey and Theresa Jain. *Science Basis for Changing Forest Structure to Modify Wildfire Behavior and Severity*. U.S. Forest Service General Technical Report RMRS-GTR-120. Rocky Mountain Research Station, 2004. http://www.fs.fed.us/rm/pubs/rmrs_gtr120.pdf.

Grand Lake Historical Society. "Harbison-Ranch." Guest Ranches of the Valley, 2012. http://grandlakehistory.org/wp-content/uploads/2012/12/Harbison-Ranch.pdf.

————. "Neversummer-Ranch." Guest Ranches of the Valley, 2012. http://grandlakehistory.org/wp-content/uploads/2012/12/Neversummer-Ranch.pdf.

————. "Neversummer-Ranch-Pics-2003." Guest Ranches of the Valley, 2003. http://grandlakehistory.org/wp-content/uploads/2012/12/Neversummer-ranch-pics-2003.pdf.

————. "Phantom-Valley-Ranch." Guest Ranches of the Valley, 2012. http://grandlakehistory.org/wp-content/uploads/2012/12/Phantom-Valley-Ranch.pdf.

Grant, Michael C. "The Trembling Giant." *Discover Magazine*, October 1, 1993. http://discovermagazine.com/1993/oct/thetremblinggian285/?searchterm=The%20Trembling%20Giant.

Hansen, Wallace R. *Climatography of the Front Range Urban Corridor and Vicinity, Colorado: A Graphical Summary of Climatic Conditions in a Region of Varied Physiography and Rapid Urbanization.* Geological Survey Professional Paper. Washington, D.C.: U.S. Government Printing Office, 1978.

Haupt, Lyanda. *Crow Planet: Essential Wisdom from the Urban Wilderness.* 1st ed. New York: Little, Brown and Company, 2009.

Hicks, Davidson, Mel Busch, Bill Lambdin and Lee Netzler. "Lord Dunraven." Glen Haven Historical Society. http://www.ghhs.us/Dunraven.htm.

Hoffman, Matt. "Glaciers of Colorado." Glaciers of the American West, August 31, 2011. http://glaciers.us/glaciers-colorado.

Hosokawa, Bill. *Colorado's Japanese Americans: From 1886 to the Present.* Boulder: University Press of Colorado, 2005.

Hughes, J. Donald. *American Indians in Colorado.* 2nd ed. Boulder, CO: Pruett Pub. Company, 1987.

Ice Age Hunters of the Rockies. Niwot [Denver]: Denver Museum of Natural History; University Press of Colorado, 1992.

Johnson, Kirk R., and Denver Museum of Nature and Science. *Ancient Denvers: Scenes from the Past 300 Million Years of the Colorado Front Range.* Denver, CO: Denver Museum of Nature & Science, 2003.

Kaufmann, Merrill R., Thomas T. Veblen and William H. Romme. "Historical Fire Regimes in Ponderosa Pine Forests of the Colorado Front Range, and Recommendations for Ecological Restoration and Fuels Management." Colorado Forest Restoration Institute, November 7, 2006. http://frontrangeroundtable.org/uploads/CFLRP_CFRIPonderosa.pdf.

Kiley, Elizabeth Mills, and Edna Mills Kiley. "Enos A. Mills—One Man's Contributions Can Be Important to Society." Sangre-de-Cristo, 1995. http://sangre-de-crsisto.com/estespark/storiesw/ENOS.html.

Kingery, Hugh. *Birding Colorado: Over 180 Premier Birding Sites at 93 Locations.* 1st ed. Guilford, CT: FalconGuides, 2007.

Kochert, M.N., K. Steenhof, C.L. McIntyre and E.H. Craig. "Golden Eagle (*Aquila chrysaetos*)." Edited by A. Poole and F. Gill. The Birds of North America Online. http://bna.birds.cornell.edu/bna/species/684 2002. doi:10.2173/bna.684.

Laubach, Christyna M., Rene Lauback and Charles W.G. Smith. *Raptor!: A Kid's Guide to Birds of Prey.* North Adams, MA: Storey Books, 2002.

Leatherman, D.A. "Mountain Pine Beetles in Ponderosa Pine." Presented at the Rocky Mountain BioBlitz, Rocky Mountain National Park, August 25, 2012.

Leatherman, D.A., I. Aguayo and T.M. Mehall. "Mountain Pine Beetle." Colorado State University. http://csfs.colostate.edu/pages/mountain-pine-beetle.html.

———. "Mountain Pine Beetle Fact Sheet No. 5.528." Colorado State University Extension. http://www.ext.colostate.edu/pubs/insect/05528.html.

Lively, Dave. Harbison family, Personal communication, telephone, October 13, 2014.

Lowery, James. *The Tracker's Field Guide: A Comprehensive Handbook for Animal Tracking in the United States*. Guilford, CT: FalconGuide, 2006.

Manahan, Stanley E. *Environmental Chemistry*. 4th ed. Monterey, CA: Brooks/Cole Publishing, 1984.

Marzluff, John, and Tony Angell. *In the Company of Crows and Ravens*. New Haven, CT: Yale University Press, 2005.

McCreary, Jeremy. "Colorado Geology Photojournals: A Tribute to Colorado's Physical Past and Present." Cliffshade. http://www.cliffshade.com/colorado/geo_overview.htm#uinta.

McTighe, James. *Roadside History of Colorado*. Rev. ed. Boulder, CO: Johnson Books, 1989.

McWilliams, Barry. "Raven and the First Men." Eldrbarry's Raven Tales, 1997. http://eldrbarry.net/rabb/rvn/first.htm.

Miller, Albert. *Meteorology*. Columbus, OH: Charles E. Merrill Publishing Company, 1976.

Mitten, Jeff. "Clark's Nutcrackers Face Lean Times." *Boulder Daily Camera*, September 11, 2014. http://www.dailycamera.com/News/ci_26516577/Jeff-Mitton:-Clarks-Nutcrackers-face-lean-times.

Moseman, Andrew. "Meet the Genius Bird: Crafty Crows Use Tools to Solve a Three-Step Problem." *Discover Magazine*, April 21, 2010. http://blogs.discovermagazine.com/80beats/2010/04/21/meet-the-genius-bird-crafty-Crows-use-tools-to-solve-a-three-step-problem.

Munn, Barbara J. "Metamorphism in the Northern Front Range, Colorado." PhD diss., Virginia Polytechnic Institute and State University, 1997. http://scholar.lib.vt.edu/theses/available/etd-0998-19597/unrestricted/MunnDiss.pdf.

Musselman, Lloyd K. *Administrative History, 1915–1965: Rocky Mountain National Park*. U.S. National Park Service, July 1971. E-book, January 15, 2004. http://www.nps.gov/parkhistory/online_books/romo/adhi.htm.

Mutel, Cornelia Fleischer, and John C. Emerick. *From Grassland to Glacier: The Natural History of Colorado and the Surrounding Region*. 1st ed. Boulder, CO: Johnson Books, 1984.

National Climatic Data Center, National Oceanic and Atmospheric Administration. "Drought: A Paleo Perspective." http://www.ncdc.noaa. gov/paleo/drought/drght_home.html.

National Weather Service. "Lightning Safety Outdoors." http://www. lightningsafety.noaa.gov/fatalities.htm.

———. "NWS Lightning Safety." http://www.lightningsafety.noaa.gov/ media.htm.

Natural Diversity Information Source, Colorado Division of Wildlife. "NDIS American Elk Wildlife Page." http://ndis.nrel.colostate.edu/ wildlifespx.asp?SpCode=051001.

Nelson, Mike P. *The Colorado Weather Book*. Englewood, CO: Westcliffe, 1999.

Nelson, Ruth Ashton. *Handbook of Rocky Mountain Plants*. 4th ed. Niwot, CO: Roberts Rinehart Publishers, 1992.

Nesom, Guy. "Plant Guide Blue Spruce." USDA NRCS Plant Data Center, 2002. http://plants.usda.gov/plantguide/pdf/pg_pipu.pdf.

———. "Plant Guide Englemann Spruce." USDA NRCS Plant Data Center, 2003. http://plants.usda.gov/plantguide/pdf/pg_pien.pdf.

———. "Plant Guide Quaking Aspen." USDA NRCS Plant Data Center, 2003. http://plants.usda.gov/plantguide/pdf/cs_potr5.pdf.

———. "Plant Guide Subalpine Fir." USDA NRCS Plant Data Center, 2006. http://plants.usda.gov/plantguide/pdf/pg_abla.pdf.

Newton, Darin. "Bear Population and Stability." January 2008. http:// www.nps.gov/romo/parkmgmt/upload/bear-population.pdf.

O'Neil, Dennis. "Human Biological Adaptability: Adapting to High Altitude." Palomar College. http://anthro.palomar.edu/adapt/ adapt_3.htm.

Patterson, Kyle. "2012 Visitation Stats Released for Rocky Mountain National Park." U.S. National Park Service, February 12, 2013. http:// www.nps.gov/romo/parknews/pr_2012_visitation_stats.htm.

Peoria Zoo, Glen Oak Zoo. "Lagomorph Fact." http://www.glenoakzoo. org/RodentTAG/lagomorph_fact.htm.

Perry, Phyllis Jean. *It Happened in Rocky Mountain National Park*. 1st ed. Guilford, CT: TwoDot, 2008.

Pettit, Jan. *Utes, the Mountain People*. N.p.: Johnson Books, 1990.

Pickering, James H. *Mr. Stanley of Estes Park*. 1st ed. Kingfield, ME: Stanley Museum, 2000.

Porter, William. "Colorado Floods: A By-the-Numbers Look at All that Water." *Denver Post*, September 14, 2013. http://www.denverpost.com/ news/ci_24093363/colorado-flooding-by-numbers-look-at-all-that.

Preston, C.R., and R.D. Beane. "Red-Tailed Hawk (*Buteo jamaicensis*)." The Birds of North America Online. Edited by A. Poole. Cornell Lab of Ornithology, 2009. Retrieved from the Birds of North America Online. http://bna.birds.cornell.edu/bna/species/052. doi:10.2173/bna.52.

RA Mueller Inc. *Atmospheric Pressure, Barometer Reading and Boiling Point of Water*. Pump handbook. http://www.rampump.com/handbook/atmosphere.html.

Raup, Omer B., U.S. Geological Survey and Rocky Mountain Nature Association. *Geology Along Trail Ridge Road: Rocky Mountain National Park, Colorado*. 2nd ed. Estes Park, CO: Rocky Mountain Nature Association, 2005.

Reynolds, Amanda C., Julio L. Betancourt, Jay Quade, P. Jonathan Patchett, Jeffery S. Dean and John Stein. "87Sr/86Sr Sourcing of Ponderosa Pine Used in Anasazi Great House Construction at Chaco Canyon, New Mexico." *Journal of Archaeological Science* 32 (2005): 1,061–1,075.

Robertson, Janet. *The Magnificent Mountain Women: Adventures in the Colorado Rockies*. Lincoln: University of Nebraska Press, 1990.

Rombauer, Irma von Starkloff, and Marion Rombauer Becker. *The Joy of Cooking*. New York: Scribner, 2006.

Sampson, George Roger, David R. Betters and Robert N. (Robert Noakes) Brenner. *Mountain Pine Beetle, Timber Management, and Timber Industry in Colorado's Front Range: Production and Marketing Alternatives*. U.S. Department of Agriculture. Fort Collins, CO: Rocky Mountain Forest and Range Experiment Station, Forest Service, 1980.

Savage, Candace. *Bird Brains: The Intelligence of Crows, Ravens, Magpies, and Jays*. San Francisco: Sierra Club Books, 1995.

Sherriff, Rosemary L., Rutherford V. Platt, Thomas T. Veblen, Tania L. Schoennagel and Meredith H. Gartner. "Historical, Observed, and Modeled Wildfire Severity in Montane Forests of the Colorado Front Range." *PLoS ONE* 9, no. 9 (2014). e106971. doi:10.1371/journal. pone.0106971.

Simmons, Michele. Personal communication, Rocky Mountain National Park, September 2014.

Sims, Lesley, and Jane Chisholm. *The Usborne Book of Castles: Internet-Linked*. N.p.: Usborne Pub Ltd, 2002.

Smith, J.P. *Vascular Plant Families: An Introduction to the Families of Vascular Plants Native to North America and Selected Families of Ornamental or Economic Importance*. Eureka, CA: Mad River Press, 1977.

Smith, P. David. *Ouray, Chief of the Utes*. Ouray, CO: Wayfinder Press, 1986.

Soulen, Ric. "Wolf at the Door." Blogs, Colorado Journal. *Denver Post*. http://blogs.denverpost.com/coloradojournal/2008/01/31/wolf-at-the-door.

Southern Ute Indian Tribe. "Chronology." 2010, modified November 19, 2013. http://www.southern-ute.nsn.us/history/chronology.

Stegner, Wallace. *Beyond the Hundredth Meridian: John Wesley Powell and the Second Opening of the West.* New York: Penguin Books, 1992.

Stone, Tammy. *The Prehistory of Colorado and Adjacent Areas.* Salt Lake City: University of Utah Press, 1999.

Strickland, Dan, and Henri Ouellet. "Gray Jay (*Perisoreus canadensis*)." The Birds of North America Online. Edited by A. Poole. Cornell Lab of Ornithology, 2011. Retrieved from the Birds of North America Online. http://bna.birds.cornell.edu/bna/species/040. doi:10.2173/bna.40.

Taylor, Andrew M. *Guide Book to the Geology of Red Rocks Park and Vicinity.* 1st ed. Golden, CO: Cataract Lode Mining Company, 1992.

Tekiela, Stan. *Trees of Colorado Field Guide.* Cambridge, MN: Adventure Publications Inc., 2007.

Toll, Oliver W. *Arapaho Names and Trails: A Report of a 1914 Pack Trip.* Rev. ed. Estes Park, CO: Rocky Mountain Nature Association, 2003.

Tomback, Diana F. "Clark's Nutcracker (*Nucifraga columbiana*)." The Birds of North America Online. Edited by A. Poole. Cornell Lab of Ornithology, 1998. Retrieved from the Birds of North America Online. http://bna.birds.cornell.edu/bna/species/331. doi:10.2173/bna.331.

Town of Estes Park. "Lawn Lake Flood." June 9, 2011. http://web.archive.org/web/20110609010313/http://www.estesnet.com/82flood.

———. "The Lawn Lake Flood." December 9, 2011. http://web.archive.org/web/20111209211333/http://www.estesnet.com/hydroplant/the_lawn_lake_flood.aspx.

Trost, Charles H. "Black-Billed Magpie (*Pica hudsonia*)." The Birds of North America Online. Edited by A. Poole. Cornell Lab of Ornithology, 1999. Retrieved from the Birds of North America Online. http://bna.birds.cornell.edu/bna/species/389. doi:10.2173/bna.389.

Tunis, Edwin. *Indians.* Rev. ed. New York: Crowell, 1979.

Ubbelohde, Carl, Maxine Benson and Duane A. Smith. *A Colorado History.* Rev. centennial ed. Boulder, CO: Pruett Pub. Company, 1976.

Udvardy, Miklos D.F. *The Audubon Society Field Guide to North American Birds.* New York: Knopf, 1977.

U.S. Bureau of Reclamation. "Colorado—Big Thompson Project." http://www.usbr.gov/projects/Project.jsp?proj_Name=Colorado-Big%20Thompson%20Project.

USDA Forest Service, Arapaho and Roosevelt National Forests, Pawnee National Grassland. "Fire & Aviation—Jefferson County

Tanker Base." http://www.fs.usda.gov/detail/arp/alerts-notices/?cid=fsm91_058168.

U.S. Forest Service. "Bark Beetle Management: U.S. Rocky Mountain Bark Beetle." http://www.fs.usda.gov/wps/portal/fsinternet/!ut/p/c4/04_SB8K8xLLM9MSSzPy8xBz9CP0os3gjAwhwtDDw9_AI8zPwhQoY6BdkOyoCAPkATlA!/?ss=110299&navtype=BROWSEBYSUBJECT&cid=null&navid=131000000000000&pnavid=null&position=BROWSEBYSUBJECT&ttype=main&pname=Rocky%20Mtn.%20Bark%20Beetle-%20Bark%20Beetle%20Managementhttp://www.2003firestorm.gov.bc.ca.

————. "Influence of Forest Structure on Wildfire: An Overview." U.S. Department of Agriculture, November 2003. http://www.fs.fed.us/projects/hfi/2003/november/documents/forest-structure-wildfire.pdf.

Utah State University Range Plants of Utah. "Lodgepole Pine." http://extension.usu.edu/rangeplants/htm/lodgepole-pine.

Ute Mountain Ute Tribe. "Overview & Statistics." http://www.utemountainute.com/overview_statistics.htm.

Veblen, Thomas T., and Diane C. Lorenz. *The Colorado Front Range: A Century of Ecological Change*. Salt Lake City: University of Utah Press, 1991.

Verbeek, N.A., and C. Caffrey. "American Crow (*Corvus brachyrhynchos*)." The Birds of North America Online. Edited by A. Poole. Cornell Lab of Ornithology, 2002. Retrieved from the Birds of North America Online. http://bna.birds.cornell.edu/bna/species/647.

Vranesh, George. *Colorado Citizens' Water Law Handbook: Original Edition for Colorado Endowment for the Humanities Project "Colorado Water, the Next 100 Years."* Colorado Water Resources Institute, 1991.

Walker, Lauren E., Erick Greene, William Davison and Vincent R. Muehter. "Steller's Jay (*Cyanocitta stelleri*)." The Birds of North America Online. Edited by A. Poole. Cornell Lab of Ornithology, 2014. Retrieved from the Birds of North America Online. http://bna.birds.cornell.edu/bna/species/343.

Watts, Tom, and Bridget Watts. *Rocky Mountain Tree Finder*. 2nd ed. Nature Study Guild Publishers, 2008.

Wennerberg, Sarah. "Plant Guide Ponderosa Pine." http://plants.usda.gov/plantguide/pdf/pg_pipo.pdf.

Western Regional Climate Center. Climate of Colorado. Modified October 13, 2009. http://www.wrcc.dri.edu.

————. "State Extremes [of Weather]." WRCC State Extremes. Modified November 16, 2014. http://www.wrcc.dri.edu/htmlfiles/state.extremes.html.

Willard, Beatrice E., Michael T. Smithson and Rocky Mountain Nature Association. *Alpine Wildflowers of the Rocky Mountains*. Rev. ed. Estes Park, CO: Rocky Mountain Nature Association, 2006.

Wingate, Janet L. *Rocky Mountain Flower Finder*. Rochester, NY: Nature Study Guild, 1990.

Wohlforth, Charles. "Who You Callin' 'Bird Brain'?" *Discover Magazine*, March 2010, modified August 23, 2011. http://discovermagazine. com/2010/mar/01-who-you-callin-bird-brain.

Young, Mary Taylor. *Colorado Wildlife Viewing Guide*. 2nd ed. The Watchable Wildlife Series. Helena, MT: Falcon Pub., 2000.

———. *The Guide to Colorado Birds*. Englewood, CO: Westcliffe Publishers, 1998.

———. "Wolves—Knocking at Colorado's Door." Colorado's Wildlife Company—Colorado Division of Wildlife, Summer 2004, modified October 7, 2011. http://wildlife.state.co.us/Education/TeacherResources/ ColoradoWildlifeCompany/Pages/PackCWCS04.aspx.

Yulsman, Tom. "Colorado Deluge: 'Could Be Classified as a 1,000-Year Event.'" *Discover Magazine*, September 12, 2013, modified November 15, 2014. http://blogs.discovermagazine.com/imageo/2013/09/12/ colorado-deluge-could-be-classified-as-a-1000-year-event.

———. "Colorado Deluge: Flooding Before and After as Seen from Space." *Discover Magazine*, September 15, 2013, modified November 15, 2014. http://blogs.discovermagazine.com/imageo/2013/09/15/colorado- deluge-flooding-before-after-seen-from-space.

Index

About the Author

Amy Law has been lucky enough to live near Trail Ridge Road and so has made many trips over this fascinating highway. To learn more about the natural history of Trail Ridge Road and other ecosystems, Amy earned a master's degree from the College of Natural Resources at Colorado State University. In the years since, she's spent much of her time filling in the gaps in her education. Amy lives west of Denver with her husband, two kids and two dogs.